APERTURE

British Photography: Towards a Bigger Picture

Something vital and exciting has been born out of the social and economic ferment of contemporary Britain.

The rich fabric of British photography today is woven from a hundred points of view eloquently expressed by photographers young and old, struggling to articulate an image of British life adequate to its variety and energy. Drawing inspiration from the vibrant tradition of photography in postwar Britain, these picturemakers combine a close awareness of the formal heritage of photography with a sense of theatricality and presentation borrowed from the artworld.

As it has for two centuries, the notion of landscape remains central to the British experience. Now, though, many photographers approach the land not as the idyllic pastoral arcadia of Constable or Keats, but with a more critical eye, portraying the land as a cultural artistic construct in which physical beauty and social use are combined. Other photographers focus on the turbulent and troubled texture of British society as it nears the end of a decade of profound change. Notable among these photographers are such established talents as Chris Steele-Perkins, Peter Marlow, Martin Parr, and Paul Graham, as well as younger adherents including Paul Reas, Anna Fox, Peter Fraser, and Matthew Dalziel.

Perhaps the most significant shift in British consciousness in recent years has been the intense questioning of old certainties about such charged issues as sex, race, and class, as successive generations have challenged assumptions not only about the nature of British society but even what it means to be British. This same energy of "otherness" is expressed in a new regional vitality in the U.K., visible in the work of Scots Calum Colvin and Ron O'Donnell, who interweave sculptural and photographic form with dry humor. Helen Chadwick's evocative use of photocopy technology, Roberta Graham's suggestive transparencies, the multipanel constructions of Verdi Yahooda, and the fugue of Mari Mahr offer a fresh sense of beauty, of self-exploration. Many of these picturemakers have been inspired by the work of such artists as John Hilliard, who have expanded the medium's potential for meaning through their explorations of alternative methods of making and presenting photographic images.

This consideration of recent British photography was proposed by Mark Haworth-Booth, Curator of Photographs at the Victoria and Albert Museum, and its publication coincides with the museum's own survey exhibition of contemporary British photography entitled "Towards a Bigger Picture, Part 2," to be held from November 30, 1988 to January 15, 1989. *British Photography: Towards a Bigger Picture* charts the heady richness of these innovative attempts to reflect the changed realities of British society. The picture of Britain they leave is of a country bursting with creativity, whimsy, frustration, and rage, a place of familiar pleasures and implacable demands, of giddy hopes for the future combined with the nagging social and economic realities of the present.

THE EDITORS

Where We've Come From: Aspects of Postwar British Photography

By Mark Haworth-Booth

Sexual intercourse began
In nineteen sixty-three
(Which was rather late for me)—
Between the end of the Chatterley *ban*
And the Beatles' first LP.

This is the opening stanza of *"Annus Mirabilis,"* by Philip Larkin, who constitutes almost a one-man tradition in postwar English poetry. His lines make fun of arbitrary retrospective chronologies and questions like "When did contemporary British photography begin?" However, it is worth asking the question in order to raise another one: is there an identifiable tradition behind photography in Britain now? A striking difference between expressive photography in the United States and Britain, or for that matter any other country, is that in the U.S. a canon of photographic art has been articulated in a comprehensible form. Perhaps the same is true of jazz. The efforts of such individuals as Alfred Stieglitz, Beaumont Newhall, and Edward Steichen, and of a number of important institutions including the Museum of Modern Art in New York and George Eastman House in Rochester, have given American photography

BILL BRANDT, Belgravia, London, 1951

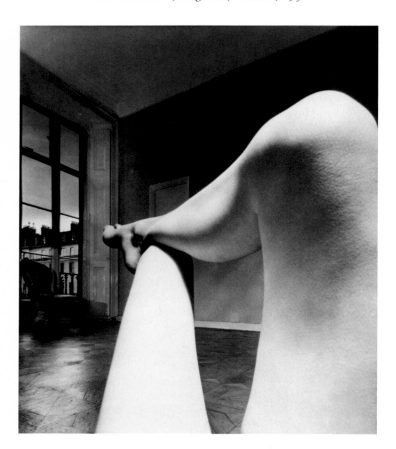

a degree of self-awareness, a sense of continuity and direction, that for the most part has been lacking in Britain and elsewhere. However, in the last fifteen or twenty years photographers in Britain have made good the omissions of their native institutions by adopting a large part of the American tradition as their own.

For some, contemporary photography began in 1970 at the Hayward Gallery on London's South Bank. The exhibition rooms were painted black, the photographs were by Bill Brandt—and they had been selected by John Szarkowski, Director of the Department of Photography at the Museum of Modern Art, New York, where the exhibit had originated the previous year. The catalogue essay was by the one art historian in Britain who concerned himself seriously with the medium of photography, Professor Aaron Scharf—an expatriate from California. Scharf closed his essay with a warning and a witticism: "We have become used to treating photographs as pictorial ephemera, and at the connivance of photo-mechanical reproduction are in danger of treating all art that way. I once saw a lady, an intelligent-looking and presentable lady, rushing up the great inner staircase of the Louvre, shouting with a frantic note in her voice, 'Guard! Quick! The Mona Lisa! Where is she? I'm double-parked!' Don't go to Brandt in that way. The longer you look, the more you'll find and so much richer will be your experience."[1] After its London showing the exhibition was toured by the Arts Council of Great Britain to twelve other U.K. venues, and was received with acclaim. The exhibition prepared a new audience, as well as a new generation of critics, for the great enlargement of photographic activity that followed in the 1970s.

It was perhaps inevitable that such an important exhibition would have featured Brandt's work. As Larkin had in poetry, Brandt constituted almost a one-man tradition in British photography. Is there a British photographer who has not learned from him? Any reservations photographers have about Brandt's print style or quality or, for some, the wide-angle distortions of his nudes, always seem peripheral matters. Brandt's reticence made it easier for him to be admired creatively—he invited imaginative esteem. His life, like his work, left a great deal to the imagination.[2] Although he loved working on commissions he was to become a model for the independent photographers of the 1970s and '80s. Through his work, shown and collected by the Museum of Modern Art, New York, from 1948 on, and by the Victoria and Albert Museum in London from 1965 on, Brandt not only demonstrated the creative possibilities of the photographic medium when allied with imagination and intellect, but also provided an image of integrity.

While Brandt became a major source of inspiration, other postwar photographers offered alternative precedents. Or was

John Deakin (1912–72) more a "case" than a precedent, an example of photography's poor image of itself? In 1985 Deakin's work, or at least its mutilated remains, was assembled by his friend Bruce Bernard for an overdue memorial exhibition at the V&A: *John Deakin, The Salvage of a Photographer*. No one who saw that exhibition will easily forget Deakin's portrait of Francis Bacon, shown in all its tattered majesty, and made at about the same date (before, during, or after has not been settled) as Lucian Freud's closely related painting of Bacon owned by the Tate Gallery. Deakin was part of Soho, London's creative powerhouse of the 1950s. His subjects, often his friends, included poets (Dylan Thomas, George Barker, W. S. Graham); painters (Bacon, Freud, John Minton, even Picasso); more or less *maudits* young writers like Oliver Bernard, the distinguished translator of Apollinaire; Muriel Belcher, who presided over the famous afternoon drinking club, The Colony Room; and—most dubious character of all—Gerald Hamilton, who twenty years earlier had provided Christopher Isherwood with the model for Mr. Norris in *Mr. Norris Changes Trains* (1935).

Bernard helped Deakin hang an exhibition of his photographs in David Archer's bookshop in Greek Street, Soho, in 1956. "Nearly all the pictures in that exhibition have been lost," Bernard wrote in the catalogue for his 1985 show, "together with their negatives, though a few tattered remains can be seen here. And they were lost because John Deakin did not really want to be a photographer, he wanted to be a painter. His paintings were not very good, though, and entirely lacked the extraordinary objective rigor of his photography, which seemed to me so impressively unblinking and lacking in 'style,' humor, or sentiment. He seemed more of an acute and unmerciful eye than a 'photographer'. . . ." To Francis Bacon, writing in the same catalogue, Deakin's portraits "are the best since Nadar and Julia Margaret Cameron." Deakin's portraiture was an embodiment of his times and his own nature, perennially at large in the York Minster pub in Dean Street, where—in fellow photographer Daniel Farson's words—"his face twisted into a comic grimace as his livid eyes raked the bar for victims," or causing consternation at parties where, frequently uninvited, he sent the glasses flying. " 'It's only gin,' he'd protest as the host frantically mopped the priceless Wilton, 'and gin doesn't stain.' "[3]

It is not surprising that Deakin's art should be associated with the painters of the School of London, whose members have given close attention to the expressive manipulation of photography. It is unmistakably apparent, for example, in Freud's unremitting and affectless scrutiny, in Bacon's borrowings from Eadweard Muybridge, in R. B. Kitaj's from Brandt, and in David Hockney's from himself. It was through the American painter Kitaj that a new generation discovered Nigel Henderson (1917–85). Kitaj included one of Henderson's "stressed" photographs in his polemical exhibition *The Human*

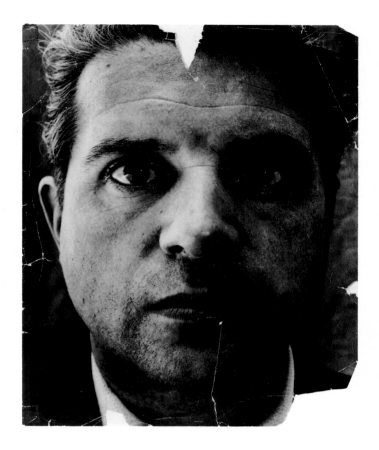

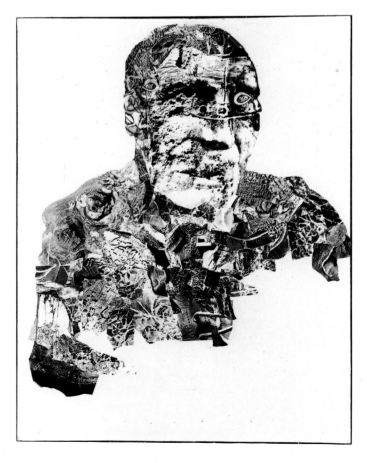

(*top*) JOHN DEAKIN, Francis Bacon, c. 1951
(*bottom*) NIGEL HENDERSON, Head of a Man, 1956

Clay, shown at the Hayward Gallery in 1976. This exhibition and catalogue, with its title from W. H. Auden, was Kitaj's declaration of faith in figuration. The Henderson piece, now in the collection of the Arts Council of Great Britain, weirdly and wonderfully stretched a human figure into the likeness of a column. However, perhaps the most potent photographic image of the English 1950s is Henderson's "Head of a Man" (1956) in the Tate Gallery. This impressive photographic collage was made for the "Patio and Pavilion" section of the exhibition *This is Tomorrow,* at the Whitechapel Art Gallery in 1956.[4] With this show, made up of twelve installations, popular culture decisively became an important subject of fine art. "Head of a Man," matted with bits of media junk thrown together into one existential whole, summarized the Britain of postwar austerity and its aftermath. Perhaps the piece owes much to Henderson's wartime experiences flying R.A.F. bombers—experi-

ences from which it took him years to recover—and something to his jobs teaching photography when there was virtually nothing by way of equipment with which to teach or practice, other than the cobbled together and randomly improvised. Most of all, though, the work testifies to his appetite for despised, demotic imagery. His masterwork, "Head of a Man" offered a looming new perspective: man as the intersection of a complex of technologies, including picture systems.

It was in 1956, too, that Roger Mayne (born in 1929), who admired Henderson's street photographs and would himself be photographed by Deakin, found the territory he made his own: London's North Kensington area, notably Southam Street, the same district in which Colin MacInnes set his epoch-making novel *Absolute Beginners* (1959). Mayne photographed this particular street regularly for five years. His imagery suggests a reaching out for new forms of solidarity between social classes in the early years of Britain's new welfare state and "Butskellite" (a word, based on the names of R. A. Butler and Hugh Gaitskell, that has been coined to indicate a common Labor and Con-

(left) DON McCULLIN, Hue, 1968

(right) PHILIP JONES GRIFFITHS, Napalm victim, Vietnam, 1967

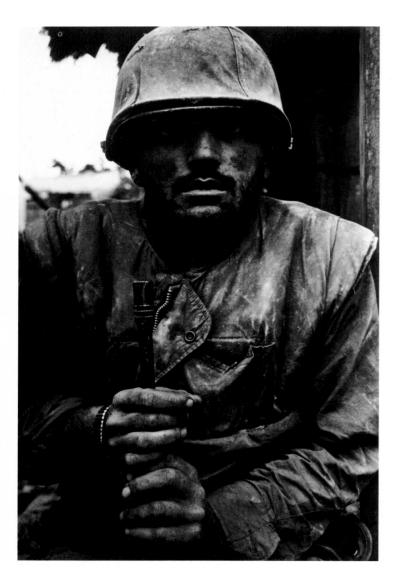

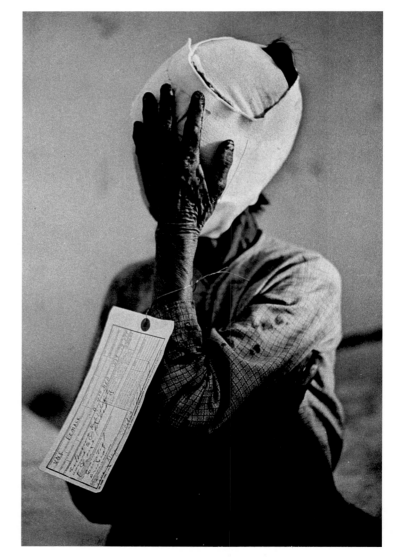

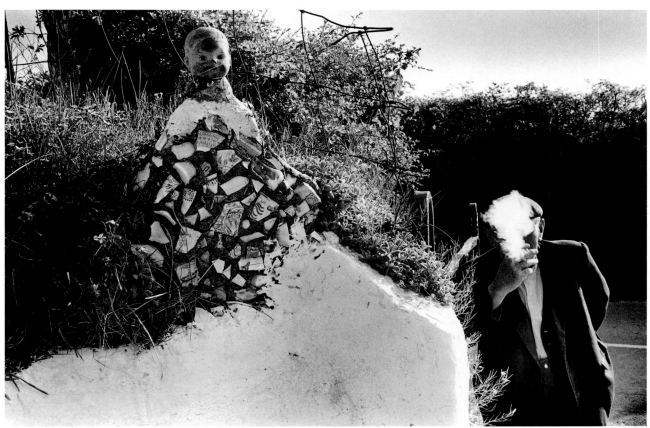

(*top*) RAYMOND MOORE, Galloway, 1980
(*bottom*) DAVID HURN, Welsh farmer with primitive sculpture

5

(*top*) THURSTON HOPKINS, London, 1959
(*bottom*) TONY RAY-JONES, Ramsgate, 1968

servative middle ground) consensus. Mayne's most famous picture from this period, of a screaming girl running toward the photographer, was taken in Southam Street on one of his first visits and was included in his first important exhibition, held at the Institute of Contemporary Arts in 1956. Interestingly, the show was reviewed in the *Times* (July 13, 1956) by Colin MacInnes, who wrote of Mayne and Deakin together:

What strikes one most, indeed, about the work of both of these artists—at a time when photography is so often concerned with spurious glamour and the "picturesque"—is their scrupulous regard for truth. And if an artist be one who, by the pictorial illusion he creates, can heighten the spectator's sense of the reality of the visible world, then both Mr. Deakin and Mr. Mayne may lay unquestionable claim to being artists of high quality.

Mayne was a partisan of Cartier-Bresson's aesthetic and was in contact with Paul Strand in Paris as well as Minor White in Rochester. With the older photographer Hugo van Wadenoyen, Mayne organized international exhibitions which included work from continental Europe and the U.S. as well as from Britain. These exhibitions were organized by the "Combined Societies," an amalgamation of photographic clubs and societies, and were mainly shown in provincial art galleries—but also, once, at the Whitechapel Art Gallery in 1953–54; in addition, the last of the series (1955–57) toured to George Eastman House and San Francisco State College in the United States. At the time Mayne wrote to the then Director of the V&A, Sir Leigh Ashton, to ask whether the museum would show the exhibitions or collect contemporary photography. Ashton's answer was crisp. Photography, he wrote back, was "a mechanical process into which the artist does not enter" (letter dated December 8, 1954).[5]

Mayne's work met with a more sympathetic response at the Museum of Modern Art in New York, where Steichen bought some examples in 1956. For many years Mayne was the only contemporary British photographer, apart from Brandt, shown in the Museum of Modern Art's permanent exhibition. From the mid 1960s on his work was also collected and circulated by the V&A, and in 1977—to mark the moment when the V&A became responsible, in the system of national museums in Britain, for the collection, preservation, and study of the art of photography—Mayne gave the Museum his "Southam Street Album."

Despite Mayne's pioneering role, British street photography of the 1970s and '80s took its cue not from him but from the brief incandescence of Tony Ray-Jones (1941–72). The mordant choreography of his imagery exercised a compelling influence on the early work of Chris Steele-Perkins, now best known for his international reporting with Magnum, and in the 1980s has been adapted to the task of describing British consumerism by Martin Parr and younger photographers who have in turn been influenced by Parr. A ferocious wit is also to be found in the work of the *Picture Post* veteran G. Thurston Hopkins, born

ROGER MAYNE, from the *Southam Street Album*, 1956–61

in 1913. After the magazine shut down in 1957 Hopkins moved into advertising, then teaching.

Teaching also harbored the talent of Raymond Moore (1920–1987), who trained as a painter at the Royal College of Art. Inspired by Otto Steinert's *Subjektive Fotografie* books (1952 and 1955) Moore began to photograph seriously in 1956, finding his initial subjects on the beaches of the Pembrokeshire coast and the island of Skomer. His work developed into an intricate, understated art that seems particularly English in its simultaneous exploration of the photographic gray scale and the nuances of a predominantly northern (gray) climate, producing images that are at once down to earth, steeped in melancholy, and broken with serendipitous illuminations. He found a friend and a fine exponent in the American poet Jonathan Williams, who wrote in *The Independent* (October 7, 1987) after Moore's untimely death:

I have met no one in England with that beady eye of his. Very much the somber, ancient albatross, with his sea-captain's beak and his (always) black sweater. He loved the act of seeing. His photographs are filled with extraordinary little

7

touches and visual nuances. There is the one of the house called Allonby, *1982, perhaps the ugliest house one has ever seen, yet full of magical detail: white wires, black wires, little bits of black this-and-that popping up here and there, illusive reflections, grasses, odd shadows indeed. What a relief his pictures are in a claustrophobic, bland country.*

When Don McCullin went the rounds of newspaper offices in London at the end of the 1950s with his pictures of teenagers, he found that his work was constantly compared to Mayne's. From the time of his reports on the civil war in Cyprus in 1964, though, McCullin's photography became recognizably his own. A generation became acquainted with the world's disasters through McCullin's photographs, usually as published in the pages of the *Sunday Times Magazine*. No doubt many people in Britain can remember exactly where they were when they saw McCullin's photographs from Hue (*Sunday Times Magazine*, March 24, 1968; see also the *New York Times*, February 28, 1968). In 1983, however, when Britain conducted its own hostilities in the South Atlantic after the Argentinian invasion of the Falkland Islands, McCullin was barred from photographing the conflict by the Ministry of Defence. Later the *Sunday Times* was acquired by Rupert Murdoch, and became a different kind of newspaper. In an interview with *Granta* (Winter, 1984), McCullin unburdened himself: "I still work for the *Sunday Times*, but they don't use me. I stand around in the office, and don't know why I'm there. The paper has completely changed: it's not a newspaper, it's a consumer magazine, really no different from a mail-order catalogue. And what do I do, model safari suits?"

Recently McCullin's work, thinly disguised, took its place in fiction, appearing in Graham Swift's novel *Out of This World* (1988). Perhaps fiction is a key word for what has occurred in photography in the past decade or two. Chris Killip, the most important realist photographer in Britain since McCullin, prefaces his book *In Flagrante* (1988) with the statement that "the book is a fiction about metaphor"—although it is clearly also about deindustrialization. I think Killip meant two things by his remark: first, that prevailing governmental views about contemporary society and its antecedents are no more than fictions, which must be opposed by other, more compelling, fictions; and secondly, that since the heyday of Brandt, Mayne, Deakin, and even McCullin, photography has, for better or worse, become an art medium. Its role in providing mass information has been altered, if not replaced, by TV. But by the same token its "role" has been seen to be precisely that—simply another method of establishing illusions.

The year 1970 was significant not only because of Bill Brandt's retrospective; it was also the year of Richard Hamilton's Tate Gallery retrospective. Hamilton's work then and since has focused, as he put it in the catalogue for that exhibition, on the "transition between the painted image, the photographic image, . . . simulations of three-dimensional space, and the real thing." Included in the 1970 show was a series of

"Cosmetic Studies," in which elements of fashion photography—details of the model Veruschka's famous face, for example—were combined with such objects as a mirror in which the viewer's own face ironically confronts the world of the fashion plate.

Working in a similarly ironic, analytical manner, Hamilton was later to adapt the sacrosanct conventions of late Cézanne to the project of advertising Andrex toilet paper, in a series of pseudo-"spirited" gouache paintings. John Berger's writings and his BBC television series *Ways of Seeing* (1972) also provided liberating, penetrating discussions of the relationship between popular culture and photography. However, it is because of Hamilton's challenging presence that the more profound concerns of Pop art have remained important for every subsequent generation of art students in Britain. He is as much a presiding genius of British photography today as is Brandt. In a 1984 installation, included in a new retrospective now touring Britain, Hamilton offers a biting commentary on the state of the nation. The postwar consensus is over and the welfare state under threat of dismantlement. Hamilton's work, devised in "Orwell's year," presents a hospital bed with a TV monitor stationed in what would be the center of a prone patient's field of vision. On the screen is Mrs. Thatcher delivering an election speech. The tape is soundless, and endlessly rerun. Hamilton's installation can be seen as a direct response to what Labour Party leader Neil Kinnock recently referred to as Thatcher's "psychological warfare against the National Health service," but it reverberates with broader meanings as well.

Apart from Hamilton's work, the arrival of photography as an avant-garde art medium in Britain can be dated to the key exhibition *The New Art*, selected by Anne Seymour of the Tate Gallery and shown at the Hayward Gallery in 1972. Exhibiting artists were Keith Arnatt, Art-Language, Victor Burgin, Michael Craig-Martin, David Dye, Barry Flanagan, Hamish Fulton, Gilbert and George, John Hilliard, Keith Milow, Richard Long, Gerald Newman, John Stezaker, and David Tremlett. Among the media used by these artists were sound, video, and language, but photographs and text predominated. In 1984 Hannah Collins used a similar combination of media—sound, text, and found photographs—in her installation *Evidence in the Streets: War Damage Volumes*, shown at Interim Art, London. This work was based on photographs from local histories showing Second World War bomb damage to the Hackney, East London, area in which Collins lives. These reference photographs were enlarged to almost cinematic proportions, printed by the cyanotype process, and shown with an accompanying sound track. Where McCullin was prevented from getting anywhere near the Falklands, Collins was able to express at least some of the feelings aroused by the conflict by making use of local materials. By using cyanotype, she was also able to float historical records into the regions of memory—or prophecy—in the manner of certain moments in the films of Andrei Tarkovsky, an artist of great importance to her. Other films are part of the essential background of contemporary British photography: Peter

RICHARD HAMILTON, Just what is it that makes
today's home so different, so appealing?, 1959

Greenaway's *The Draughtsman's Contract* (1982), for its use
of the historical tableau; Richard Eyre's *The Ploughman's Lunch*
(screenplay by Ian McEwan, 1983), with its investigation of
bad faith in the making of historical—and advertising—illu-
sions; romantic realist films from regional cities, including Bill
Forsyth's *Gregory's Girl* (1980), from Glasgow, and Chris Ber-
nard's *A Letter to Brezhnev* (1985), from Liverpool, which echo
the documentary tradition revitalized by the Side Gallery in
Newcastle upon Tyne; and, finally, the sharp and witty pre-
sentation of the brutalisms and pluralisms of the new Britain
of the 1980s, the Hanif Kureishi/Stephen Frears films *My Beau-
tiful Laundrette* (1985) and *Sammy and Rosie Get Laid* (1987).

Photography in Britain now draws on many diverse sources
of inspiration. Despite this, the sense of a specifically photo-
graphic tradition has been only intermittent. (The full history
of postwar photography in Britain is in fact far richer than can
be indicated in this brief essay, and includes, for example,
Brandt's staunch ally Norman Hall, the editor of *Photography*

magazine, and the subtle Edwin Smith, as well as women pho-
tographers of the stature of Grace Robinson, of *Picture Post*,
and the portraitist Ida Kar.) However incomplete it may be,
this survey may serve as a fruitful source of ideas and imagery
for the new work of the 1990s—work that will both draw on
and challenge the traditions that have preceded it.

[1] Aaron Scharf, "The shadowy world of Bill Brandt," introduction to *Bill Brandt Photographs* (London: The Arts Council of Great Britain, 1970). [2] The record of Brandt's early career was sketched first in *Literary Britain*, as revised and published by the Victoria and Albert Museum in 1984 and reprinted in as-sociation with Aperture in 1986, and then far more fully in the Aperture mono-graph *Bill Brandt: Behind the Camera*, by David Mellor and myself (New York: Aperture, Inc., 1985). [3] *John Deakin; The Salvage of a Photographer*, with texts by Bruce Bernard, Francis Bacon, Jeffrey Bernard, Daniel Farson, and Alexandra Noble (London: The Victoria and Albert Museum, 1985). [4] As-pects of the exhibtion, including "Patio and Pavilion," were reconstructed with what seemed touching fidelity at the Clocktower in New York in 1987, and the story of the exhibition was told and analyzed in *This is Tomorrow Today: the Independent Group and British Pop Art* (New York: The Institute for Art and Urban Resources, Inc., 1987). [5] *The Street Photographs of Roger Mayne*, p. 6 (London: Victoria and Albert Museum, 1986). The V&A has played a significant role in projecting the art of photography since 1968 when Henri Cartier-Bresson's retrospective was shown, an event which changed the ethos for photography and museum-goers, and helped prepare the way for Brandt in 1970. [6] *Richard Hamilton*, introduction by Richard Morphet (London: Tate Gallery, 1970), p. 65.

Landscape and the Fall

By Chris Titterington

John Taylor's photograph of a suburban garden was taken in connection with a series he did about the interiors of ordinary homes. He was concerned to record the decorative trappings of ordinary lives, and the garden seemed a natural extension of that cultural area—the desmesne of the suburban semi-detached. Taylor's perception is foreign, however, to the way that we tend to experience gardens. We go out there to enjoy a little bit of "nature," and we actively suppress the knowledge that it is man-made to experience what we most commonly look for in nature—that is, experience of a nonhuman order, one that is "Other" than us but that we nevertheless fit well within. In this respect Taylor's garden could stand for the whole of the British countryside, for this mechanism of selective thought (or forgetfulness) is paralleled in our perception of the British landscape in general. We tend to forget that it is almost wholly culturally determined in its larger structures, that in Britain there is no wilderness. Even the national parks, with their protected moorland and forest, are the result of man's stewardship of this landscape during the period since the last ice age.

This confusion between nature and artifice has a long history. It is unlikely, for instance, that the garden of Eden was walled off from the rest of the world surrounding it. The myth of the fall deals at its heart with the rise of consciousness and man's ambivalence toward that intelligence—the minus side of the equation being the concomitant feeling of separateness from the rest of nature. Before the fall—or "rise"—we were, or were alleged to have been, fully integrated with nature, at home within the natural order. Thus the origin of the idea of paradise as a garden lies in the fact that the only analogue for a place of harmony between man and nature available to the writers of the Old Testament was that of a garden. Indeed, the probable meaning of the myth of the fall is that the whole of nature was a "garden," indeed still is a garden, that we by virtue of our consciousness are excluded from belonging to.

In Britain this confusion between the natural and the artificial is formalized in the aesthetic known as the Picturesque. The aesthetic foundations of British landscape photography up to about 1960 fall broadly within the limits of the Picturesque, understood in this context as an informal style that consciously mimics nature while at the same time improving her. Ultimately it is sanctioned, perhaps, by the fall myth in that, as the whole of nature fell from perfection along with man, such tampering with the landscape could be seen as making good the original

wrong, turning things around to the way they used to be, before nature was ruined by man's first sin. At the time of the invention of photography the Picturesque was already firmly in place as the ruling aesthetic by which landscape and images of landscape should be judged. It had already come to appear natural, more-over—to be free from values interred there by man. It had been formulated, however, some sixty years earlier by the aesthetician amateurs of the rural capitalist gentry, and follows closely the outline of their own interests and worldview. For twenty years or so after its invention, photography remained the cultural property of the members of this ruling elite, and thus the founding works of landscape in this medium conform to the Picturesque. These founding works defined the normative pictorial form from which there was little deviation until the late 1950s, when American formalism joined the Picturesque as an alternative model.

In recent years a number of photographers have confronted the pastoral ideal of the Picturesque in their work, often through the use of irony. In Elizabeth William's "Weathering the Storm," for example, a drippingly beautiful landscape literally fades away. In John Davies's "Agecroft Power Station, Salford, England," the Picturesque is brought face to face with the massive and intrusive force of industrialism, while in Hamish Fulton's triptych "Humming Heart" it is brought back to the specific reality of Fulton's walks through the landscapes he depicts.

Since the 1960s, with the beginnings of landscape-oriented conceptual art, another type of landscape photography that is in many ways antipicturesque has appeared. On one level the appearance of this new approach to landscape is the result of basic problems with the political implications of the aesthetic. For the Picturesque generally presents an image of an unproblematic and cohesive social order within the diversity of rank and degree. Both its major visual forms, in landscape gardening and painting, manipulate an image of harmony by implying a smooth formal and emblematic progression through the social and natural hierarchy. Formally, for instance, landscapes are constructed to rules that forbid abrupt division of either mass or chiaroscuro, between cottage and mansion, foreground and distance.

Another problem concerns the inherent nostalgia of the Picturesque. For if the aesthetic privileges any part of this hierarchy,

EDWIN SMITH, Stokesay Castle, Shropshire, 1959

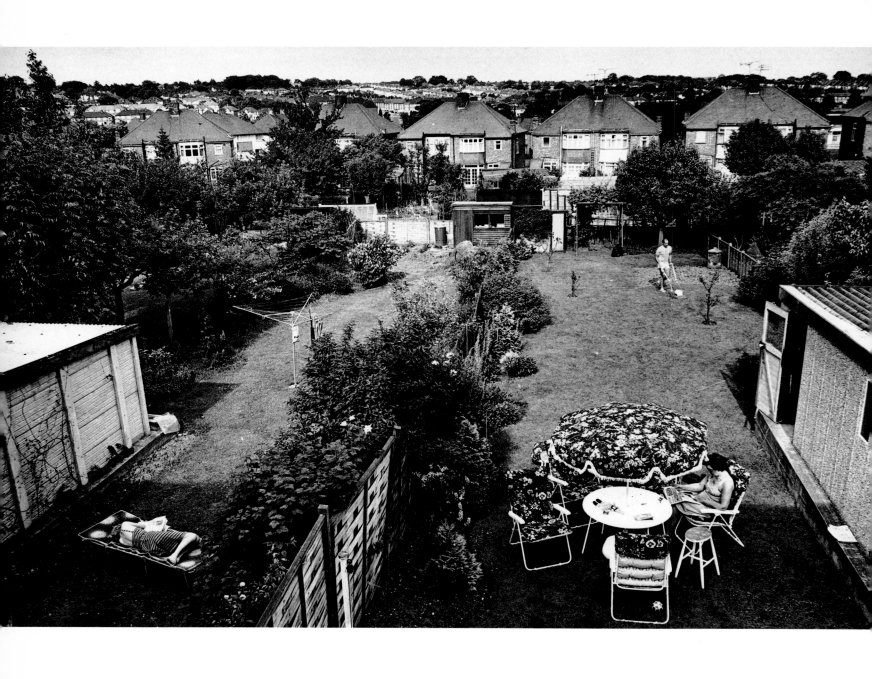

JOHN R. J. TAYLOR, North London, 1982

it is the cottage and the foreground. It idolizes the rustic dwelling and the activities of its inhabitants, and in so doing it not only ignores the realities of agricultural life, but sustains the primitivism that underpins the thinking on art over the last two hundred years that we call romantic modernism. In idolizing the simple life of the rural poor, the Picturesque must be seen as part of the antirationalism that begins in the late eighteenth century and which is at the core of romantic modern art. Antirationalism in all its manifestations—from the eighteenth-century cults of imagination, the mad, and the sketch, to the equivalents of such ideas in this century, the unconscious, the cult of child art, and the snapshot—is impelled by a perception of the divisive nature of consciousness. This quality is seen as separating man from the rest of nature, as well as dividing him internally between supposedly higher faculties and those instinctual characteristics which are closer to animal nature. We must return to the Eden myth to see this clearly for what it is. The myth of the fall concerns exactly this problem: the opening of the subject-object divide, and the beginnings of a crippling self-consciousness which turns man into an observer rather than a participant in the goings-on of the world. Romantic modernism, in all its forms, has sought to circumvent this consciousness and return us to a prelapsarian state of unselfconscious spontaneity. In identifying consciousness as the primary cause of this unease and seeking to heal the fall by effectively lobotomizing the higher faculties, romantic modernism is essentially nostalgic for a presumed Golden Age that those who reject the Picturesque must see as an Eden to escape from rather than return to.

The rejection of the precepts of romantic modernism in this sense is paralleled in another, more general sense. The idea of the garden mistaken for wilderness, of culture mistaken for nature, has obvious connections with postmodern thought. In this view the garden becomes an analogue of the mediated world. Much recent critical thought has emphasized the fact that we cannot escape from such a world. Far from offering an example of "Otherness" that we may appeal to for a standard of naturalness (the traditional value of nature), the world is seen as reflecting our own concerns. In a real way, as modern physics has shown, it is interactive with the observer, its perceived form literally created by us. This is a nature, then, that like the suburban garden is a reflection of ourselves, one that we are, in effect, locked into. But this is not to say that there is no unmediated nature outside of this. Peter Cattrell's picture appears to present an image of this state of affairs. The "garden" he depicts is selected as a part of the landscape worthy of attention under the guise of a piece of wilderness—a spot of original nature. On this hillside the practicalities of farming have deter-

H U M M I N G

H E A R T

CLOUD

ROCK

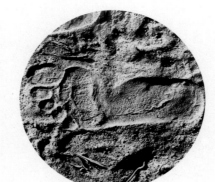

A TWENTY DAY WALKING JOURNEY FROM DUMRE TO LEDER IN MANANG AND BACK TO POKHARA BY WAY OF KUDI, NEPAL, EARLY 1983

DUST TO SNOW TO DUST

HAMISH FULTON, triptych, 1983 (*top*) Humming Heart, (*middle*) Cloud Rock, (*bottom*) "A twenty day walking journey from Dumre to Leder in Manang and back to Pokhara by way of Kudi, Nepal, early 1983," Dust to Snow to Dust

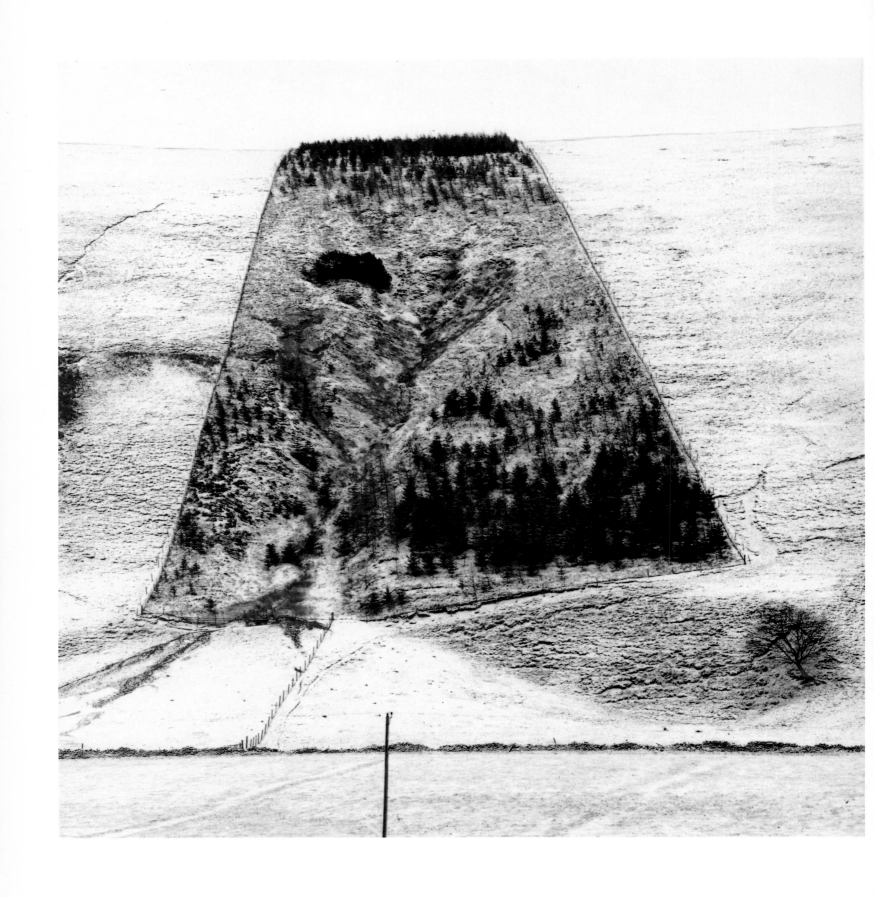

PETER CATTRELL, Fenced in Gulley, Moorfoot Hills, Scotland, January 1986

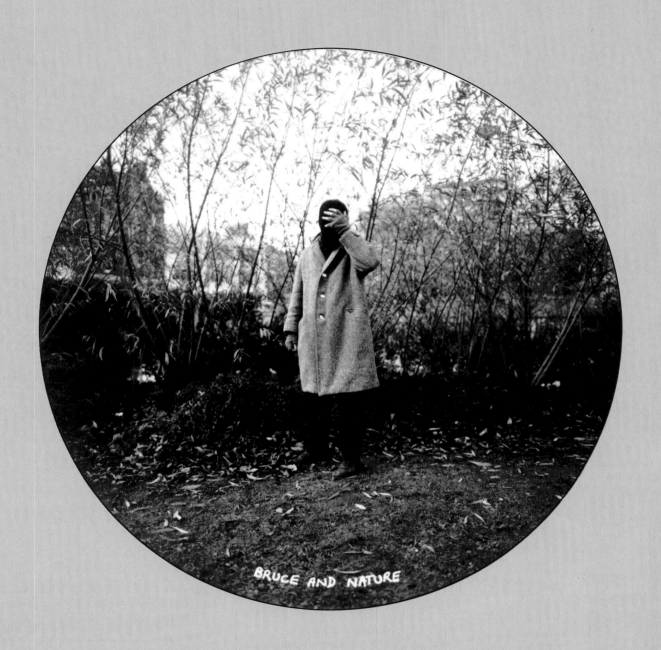

SIMON DENT, Bruce & Nature, 1986

GARRY MILLER, Reed with Eight Cuts: Summer, Autumn, Winter, 1985

ELIZABETH WILLIAMS, Weathering the Storm, 1983–85

mined that the rough area around the rivulet which is unsusceptible to domestication should be fenced off from cultivation, a few token softwoods planted for a quick cash crop. This is an original garden nature that we in our fallen state are fenced off from. But it is also a symbol of the world beyond the world of phenomena, beyond the confines of how things inevitably appear to a human observer.

The constellation of ideas that we call postmodern includes two responses to this situation. One is pragmatic and aims, by revealing the human-constructed artifice of the world, to remake it to a better design. Such artists as Cindy Sherman, Victor Burgin, and Thomas Lawson attempt to defuse the presumed naturalness of patriarchy and commonsense epistemology. The other approach is broadly pessimistic and amounts in some cases to little more than a sort of fashionable melancholy. In "Bruce and Nature," Simon Dent shows a figure overwhelmed by feeling for nature. These feelings are not, however, ones of the

confident Wordsworthian kind, a surety in the belief in nature as a benign and ultimately understandable phenomenon, but a source of profound disquiet. Bruce appears trapped in his own world, his balaclava turned the wrong way around, his senses useless in determining the actuality of his condition and unable to help him make sense of his environment.

Such realizations have affected photography in some interesting ways. Although the invention of photography may itself be seen as part of the attempt to circumvent the mediating and divisive sensibility and to make direct representation of nature possible, this may be seen as a historical rather than an absolute phenomenon. In the contemporary context photography appears now to speak of the absence of the subject rather than its presence. Garry Miller and Helen Chadwick might be thought of as reflecting landscape art in response to these concerns. Both artists use photographic technology, but in major areas of their work have abandoned the camera in an effort to

avoid a level of mediation and certain of its attendant implications. Chadwick's installation "Of Mutability" (1986) uses Xerox copies of herself collaged with Xeroxes of elements of the natural world, including, for instance, a swan, a lamb, and a skate. The central theme of the seven floor collages is that of this culture's identification of woman and nature. As such they may be seen as part of a late 1970s and '80s shift in orientation within the women's movement away from efforts toward androgyny to a concentration on the virtues of women as traditionally constructed within patriarchy. But the choice of the Xerox technique appears to have been impelled ideologically by a desire to close the subject-object divide implied in the use of conventional one-point perspective, and to achieve a more immediate directness in the physical contact of the objects depicted with the machinery that produces their images. By this means the privileged position and the remove accorded to the individual viewer is avoided, and a paradigm of a nonhier-

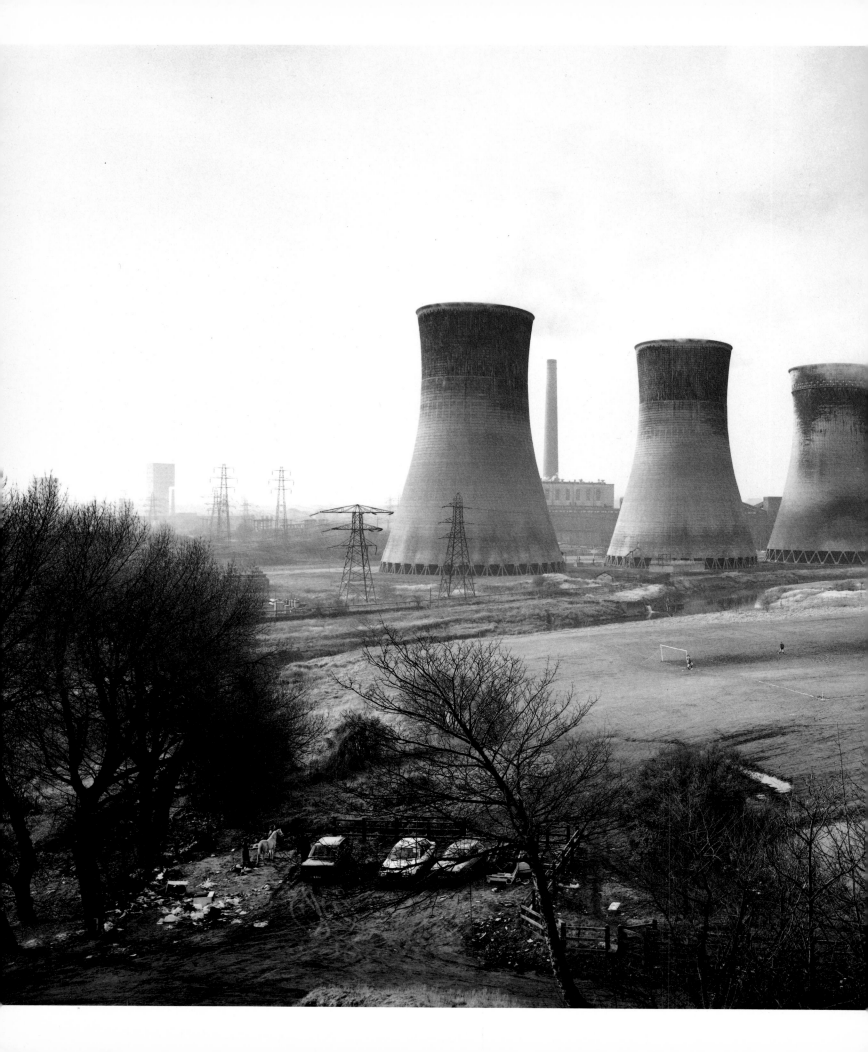

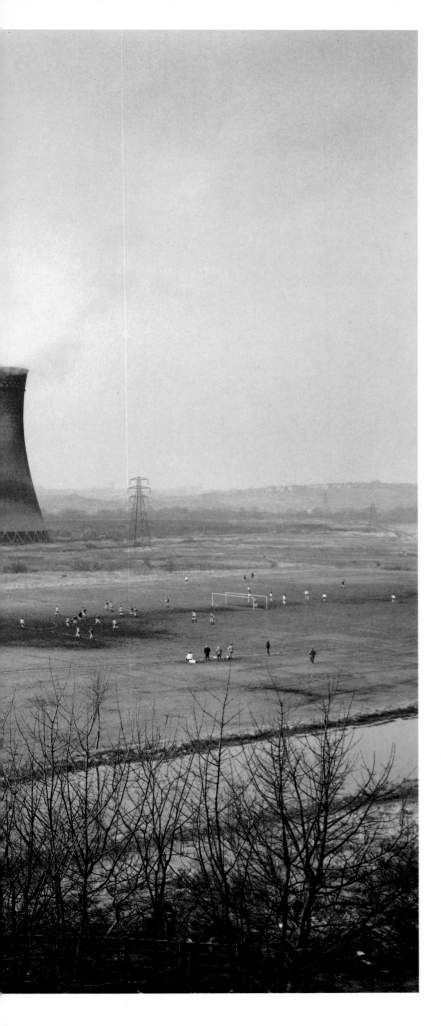

archical nature is substituted for it. Chadwick is aware, however, of the token nature of this gesture toward romantic-modern immediacy. She sees in her images the poignant absence of the objects. It is as if, having actually been in contact with the copier, the absence is more telling by virtue of the fact that only a trace is left. This impression is enhanced by the use of a blue toner which gives the effect of drowned things—of images lost at sea.

Garry Miller is a landscape artist who has also rejected conventional photographic methods. In 1984 he began his present method of working, whereby, abandoning camera and film, he gathers translucent materials from the landscape and, returning to the darkroom, places them in the head of a color enlarger where he uses them as a transparency to produce an image on Cibachrome paper. Again, the impulse to make the work in this way has its foundations in a desire for unmediated imagery born from immediate experience of the particulars of the landscape. Miller describes the experience of landscape that generally follows from the act of carrying a camera thus:

> So often the land is approached only through the camera and rarely engaged without its protection. . . . A journey is made, the place—waterfall, mountain, river—seen, recorded, and then away. Once at Hard Force waterfall I sat quietly watching the arrival of visitors. After following the signposted and fenced path, they would climb carefully down the rocks to the point nearest the surge of the falls, as if to experience its force, darkness and air. But no, they only sought the view for the picture. This taken they quickly left, delaying the experience of the moment until later with the print, at a distance and protected.

Here the emphasis seems to be upon the isolation that this mediated, "camera-bound" experience produces, and the resultant attitudes toward the environment that lead to exploitation. Such exploitation is encouraged, Miller believes, by ignorance, and the apparent power of the camera to claim the world for knowledge is in fact chimerical—the actual understanding of nature coming only through a kind of engagement that the possession of a camera seems to preclude.

But Miller's motives also have to do with a feminist-inspired refusal to adopt a dominant position "above" the landscape. Conventional Picturesque compositional methods and the prospect view are equated in this way of thinking with possession—intellectual and commercial. It is as if the pyramid of hierarchical relations has been placed on its side to become the ocular cone of perspective. In the mode of work Miller adopts, this privileging of the individual viewer in a position of command over a given landscape is avoided. His pictures use the photographic process to present the world on equal terms with the observer, as something that we must understand in the sense of its etymological meaning—to step under; in a sense, to submerge into, as participants rather than overseers.

JOHN DAVIES, Agecroft Power Station, Salford, England, 1983

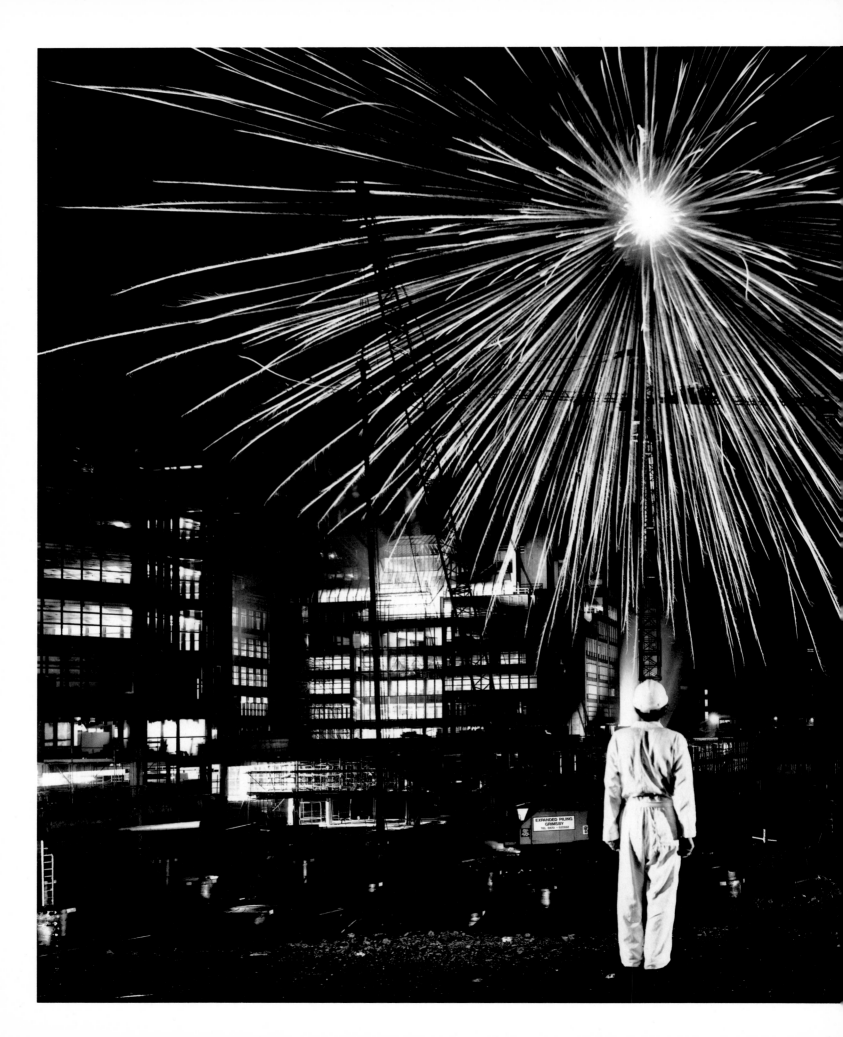

Thatcher's Britain

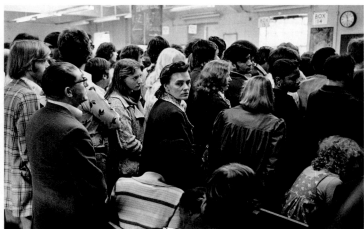

As it enters the 1990s Britain is emerging from a decade of turmoil, a period in which many of the social institutions and assumptions that had characterized British life in the postwar years have been attacked by a newly ascendant conservatism, which calls for a return to market capitalism and old-fashioned values. Two events in particular symbolize this profound shift. The Falklands War of 1983, fought with Argentina over a few barren islands thousands of miles away, could be seen as either the purest folly or the occasion for a rebirth of British pride and power. A more important touchstone for understanding the recent history of Britain was provided by the coalminers' strike of 1984–85, which, after dragging on for many months, ended inconclusively—leaving behind a legacy of renewed class strife.

Through all this British photographers have continued to record the diversity of daily life, to provide a record of this turbulent time. The photographs in this section provide a glimpse of some of the many facets of life in Britain as it leaves the 1980s. From Brian Griffin's epiphanic view of construction in the City of London to images of the British at play by Chris Steele-Perkins and Martin Parr, these photographs, in their diverse ways, provide a direct sense of the texture of life in Britain today, on the brink of a new decade.

THE EDITORS

JOHN STURROCK, Brixton Unemployment Benefit Office, 1979

(left) BRIAN GRIFFIN, Broadgate, 1986

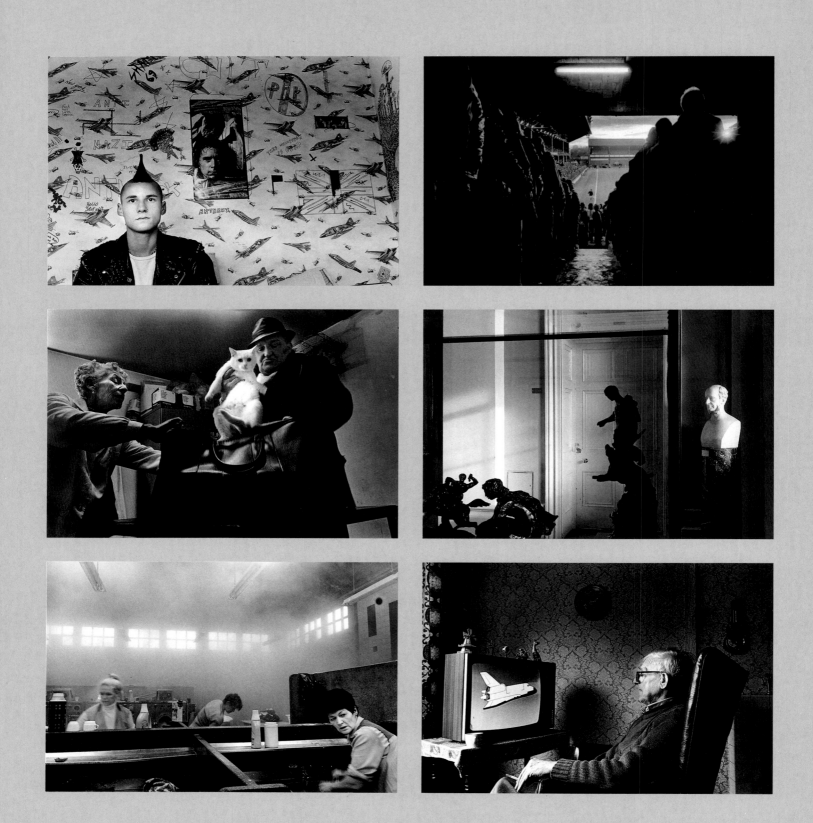

PETER MARLOW, from the *Liverpool Project*, 1987

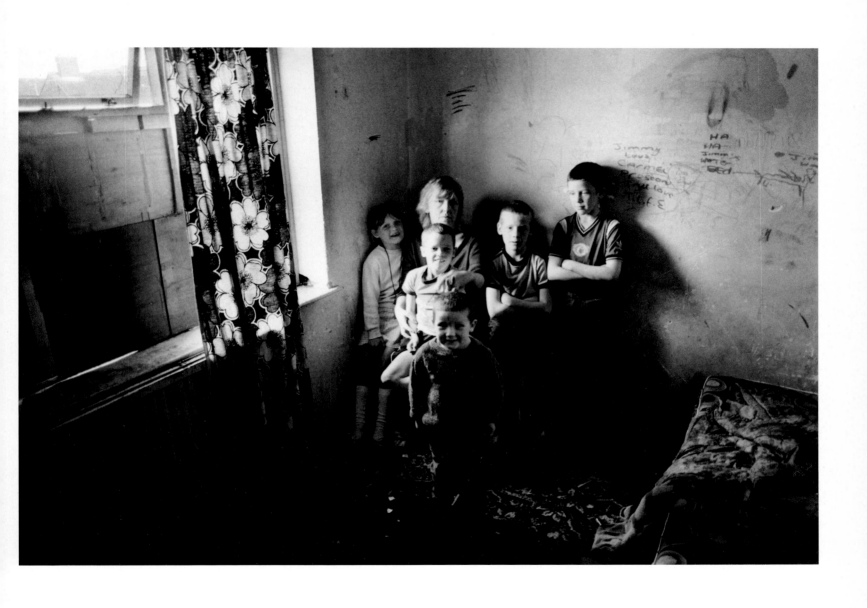

STUART FRANKLIN, Manchester, England, 1987

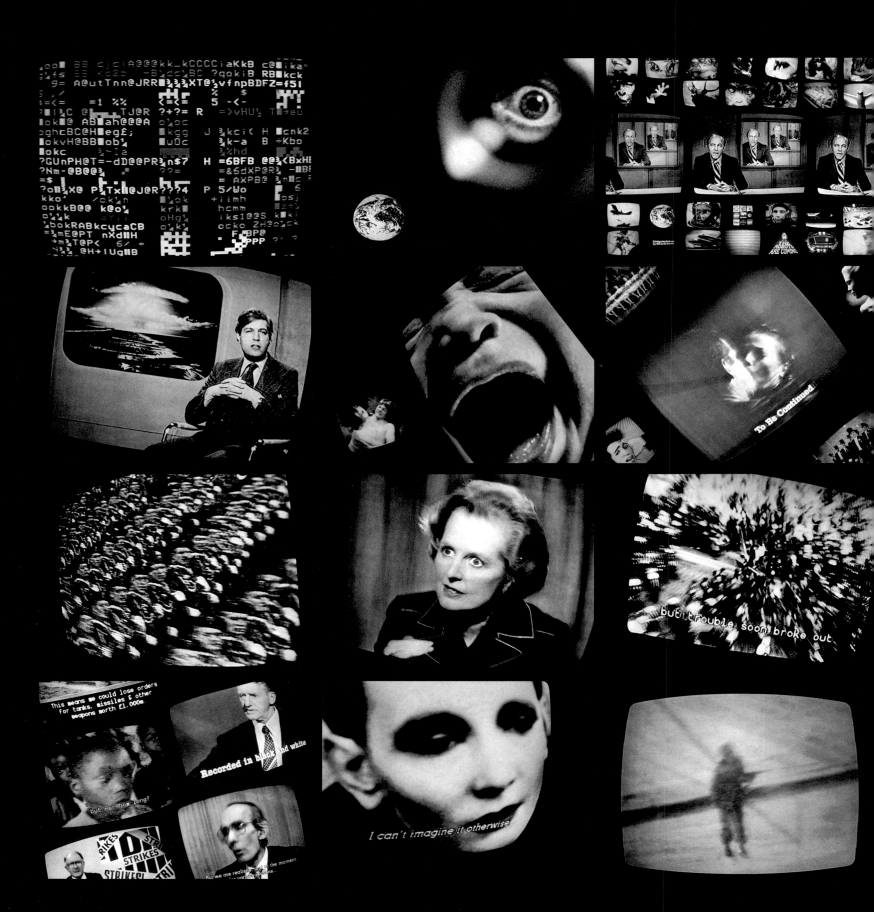

PAUL TREVOR, from *Constant Exposure*, 1987

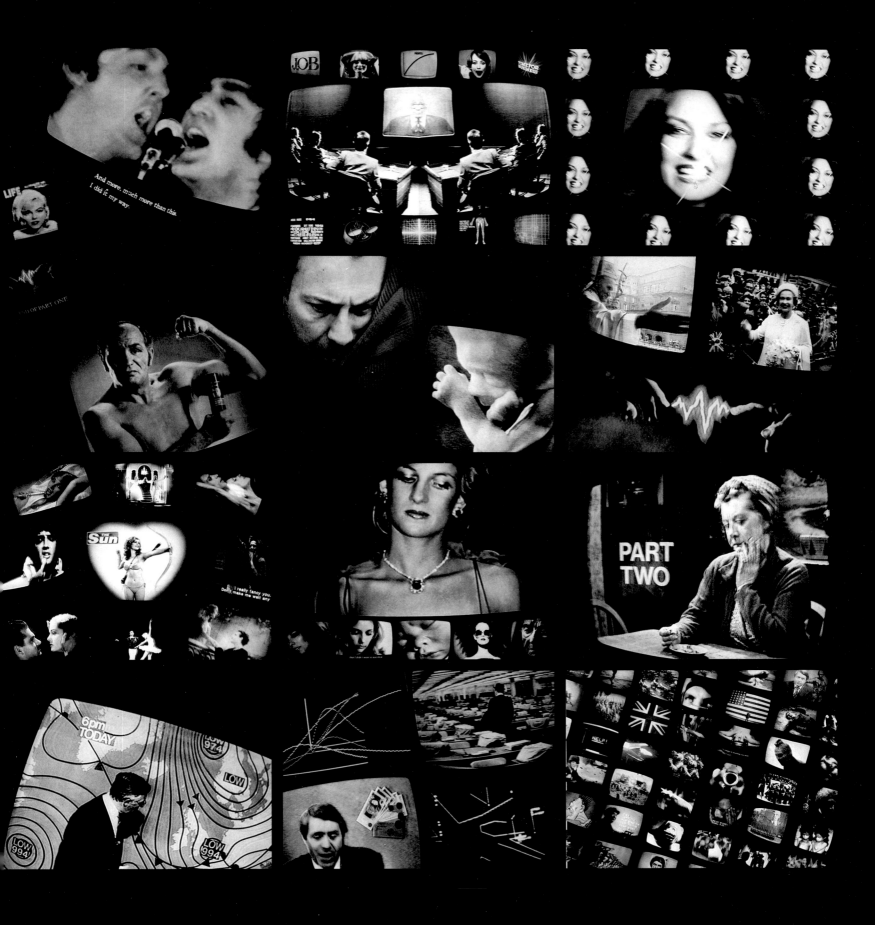

VICTOR BURGIN, (*top*) Office at Night #6, 1985–86, (*bottom*) Office at Night #4, 1985–86

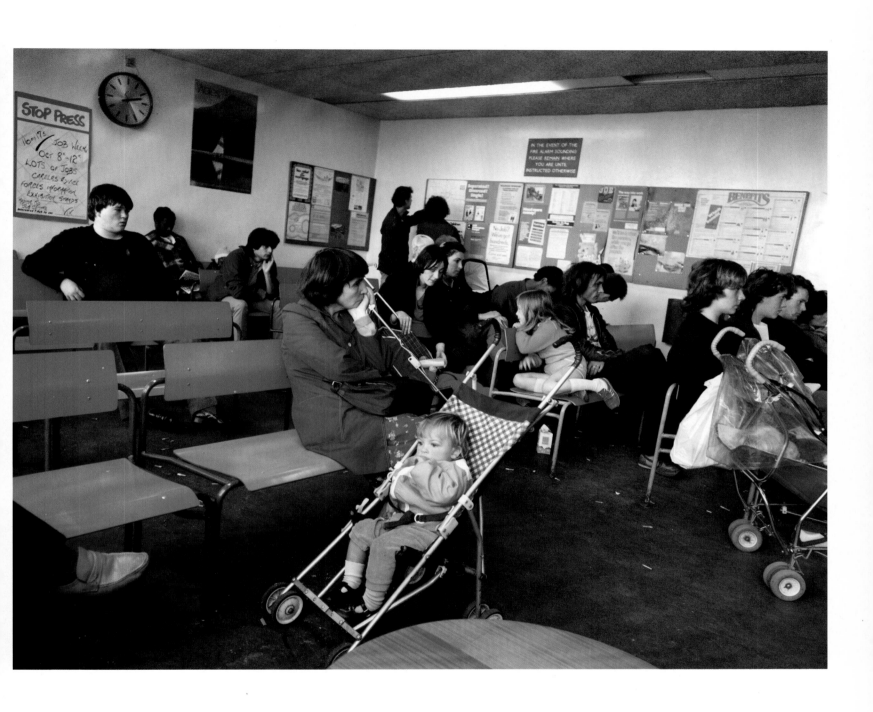

PAUL GRAHAM, Mother and baby, D.H.S.S. Office, Archway, North London, 1984

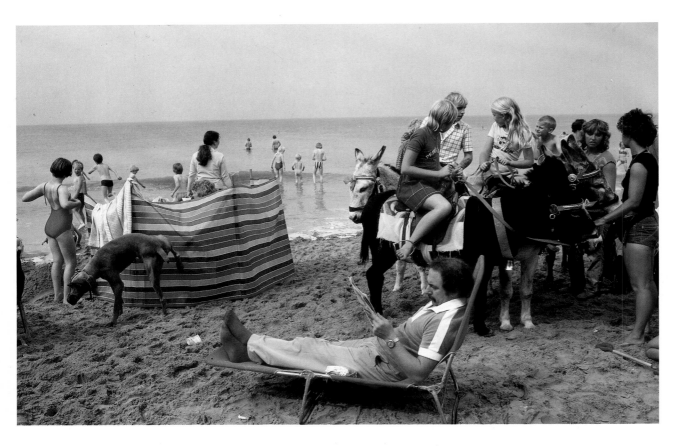

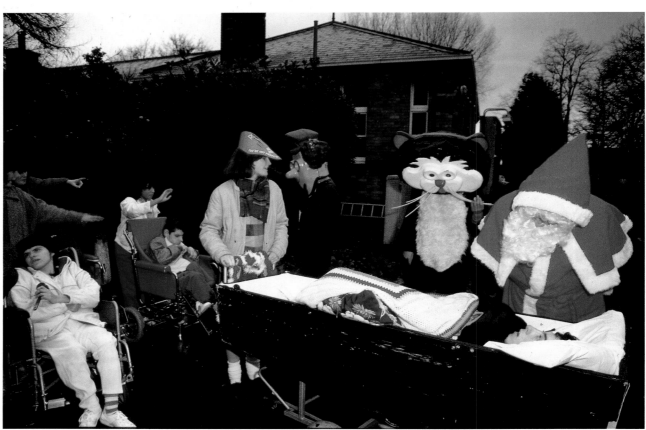

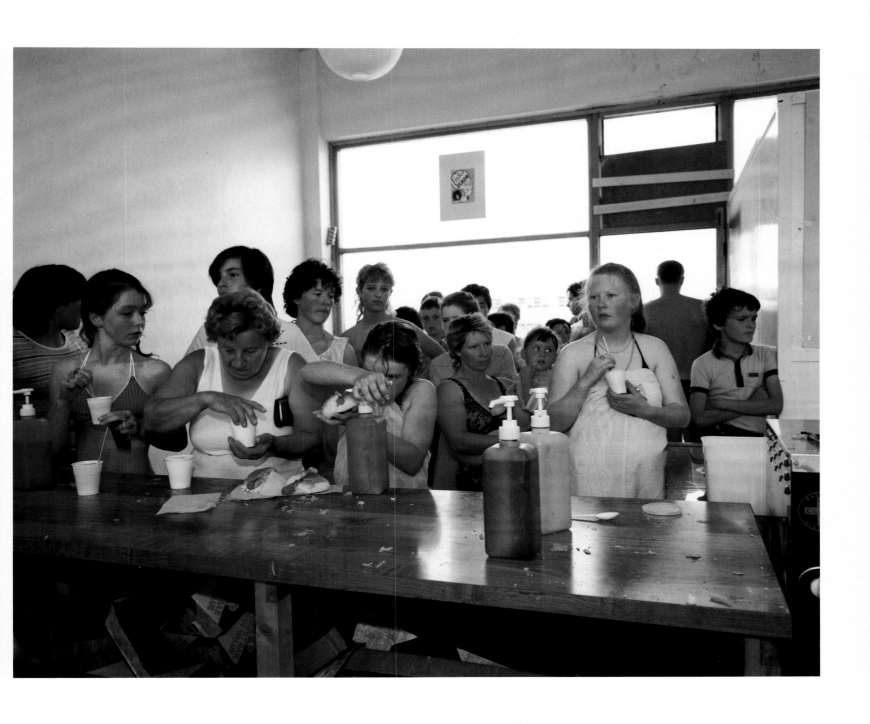

MARTIN PARR, New Brighton, from *The Last Resort*, 1986
(*opposite*) CHRIS STEELE-PERKINS, (*top*) Blackpool Beach, 1982, (*bottom*) Charity Christmas Visit to Hospital, 1986

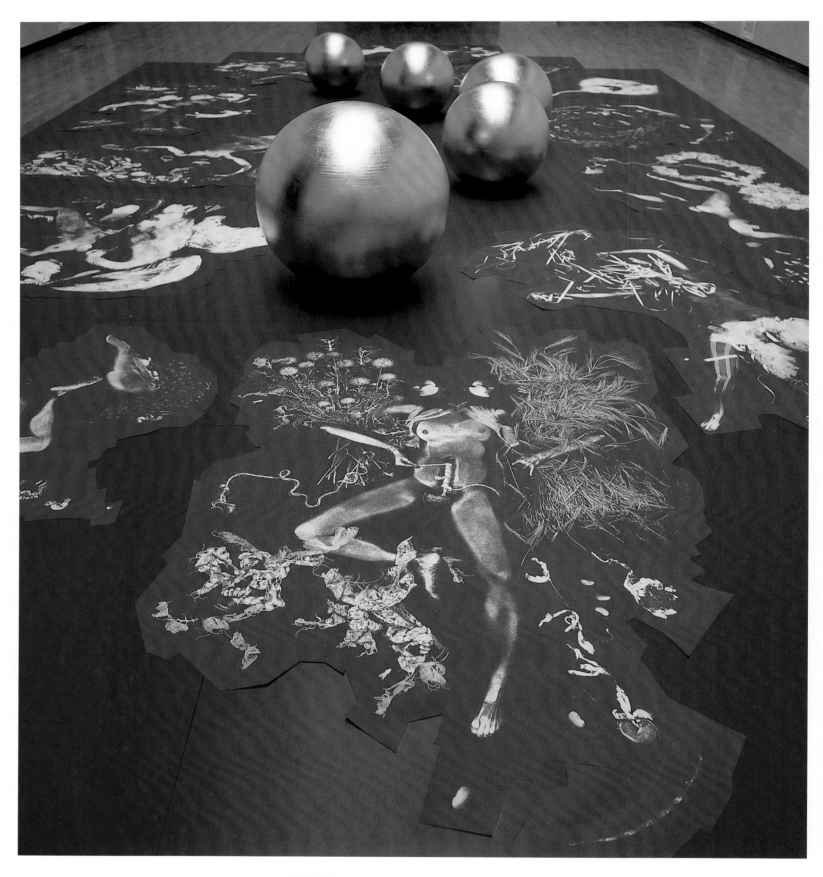

HELEN CHADWICK, The Oval Court (detail)

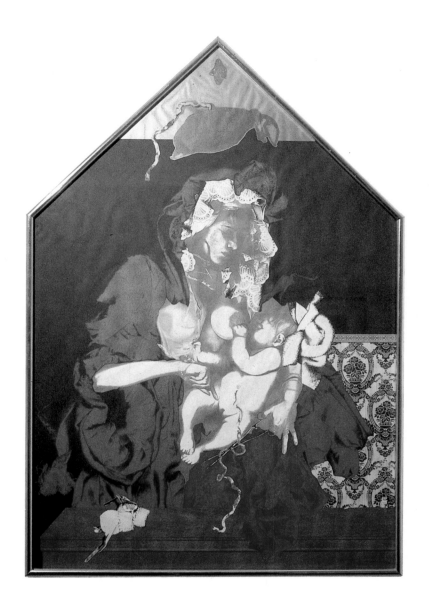

Between Frames

By Susan Butler

Between frames and across contexts, in gaps, overlaps, areas of suspension and transitivity—in such spaces, circulating between individual works and traversing national positions, some intriguing relations emerge. One unexpected collision: in 1987 the appearance, in Britain, of Keith Arnatt's series *Miss Grace's Lane* and, in America, of images by Cindy Sherman, two sets of color photographs showing terrains of scattered fragments, landscapes of dissolution. Arnatt's images are patently descriptive photographs of a dumping ground near Tintern, Gwent, while Sherman's are staged setups, images of disintegral selves dispersed within varied settings—a summer beach, an autumnal wood. Despite their different modes of construction, these two

HELEN CHADWICK, One Flesh, 1985

sets of work seem somehow to have backed into one another; do their similarities of appearance indicate anything more than simple coincidence?

A more implausible juxtaposition: recent works by Olivier Richon in Britain and Astrid Klein in Germany. Formally, the imagery of these two artists could not be more different, although a high degree of manipulation is evident in each instance. Gritty, harsh, and chilling, Klein's pictures evoke a postnuclear atmosphere scarcely imaginable other than through the complex photographic techniques by which the images are generated.

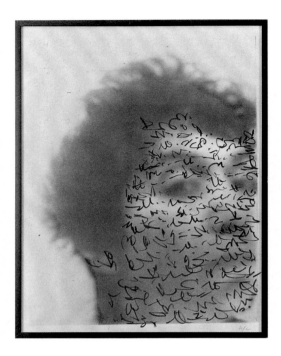

SUSAN HILLER, Midnight, Baker Street, 1983

There is a sinister ambiguity in Klein's vaguely human forms, which often seem opaque and translucent at once, and which appear in a space that is undefined yet airless. Her large, disorienting photographs discomfit the viewer immediately. Clean and precise, Richon's photographs invite the spectator with lush color and simple, clear-cut forms, in the uncomplicated space of tabletop setups. But nothing here is given in itself. The rhinoceros in one picture is a tiny toy model, the reclining lady in another a plastic figurine, and both replicas are set in curious relations to other familiar objects. No less than Astrid Klein's photographs, these too deny satisfactions of conventional reading in favor of a state of suspension in which the viewer's relation to the image and the nature of reading are placed in question.

The issue of reorientation within conditions of representation has become an increasingly important concern for a number of people·working in Britain. In many cases this concern connects their work with that of artists in other countries, as well as with current debates about representation. Central to all this is the reworking of existing cultural frames of reference, from the complex metonymic/metaphoric implications of Arnatt's images to the shifting outlines of Sue Arrowsmith's explorations of process in her work, and the different uses of framing in work by Richon, Susan Trangmar, Yve Lomax, and Susan Hiller. Hannah Collins's staged, environmental images further extend certain issues of framing; like much of the other work here, they ask viewers to consider issues posed visually in broader contexts of social and subjective positioning within culture and its systems of representation.

From Miss Grace's Lane to Howlers Hill
Sunset at the rubbish dump. A burnished light suffuses this terrain with an intimate glow familiar from the miniature Arcadian landscapes of Samuel Palmer, the nineteenth-century English visionary painter and protege of William Blake. Keith Arnatt has known the works of Palmer since boyhood; indeed, he often calls this set of pictures his "Polythene Palmers"—partly with regard to his own use of plastic paper and the intense chromatics of Fuji film. In this coexistence of painterly and technological references, one begins to gain some idea of the ironic and emotional filters brought to bear in Arnatt's imagemaking. Other painterly allusions besides Palmer might be read here; in one image a mash of decaying plastic rubbish bags creates a kind of post-Impressionist palette: juxtapositions of blue-black and rust that could be the surface of murkily reflective waters, perhaps something from late Monet. In another picture bursting trash bags suggest dystopic cornucopias, spilling forth their disintegrating contents in limitless plenitude.

Through the figure of the rubbish bag/cornucopia, a partial shift of genre is suggested, from landscape to still life. Arnatt's

ROBERTA GRAHAM, Life Sighs In Sleep (detail), 1983

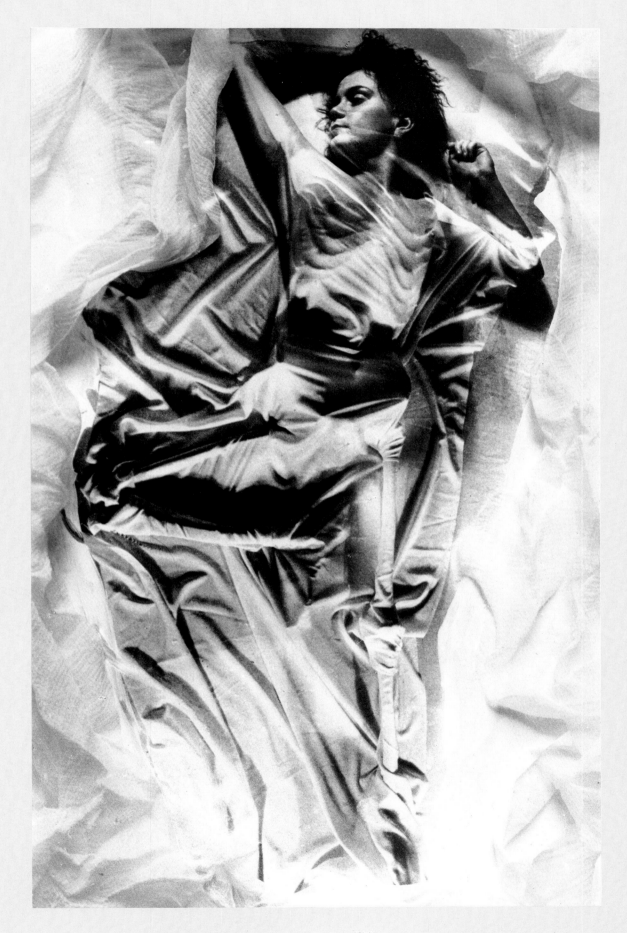

SUE ARROWSMITH, Her Familiar Dancing, 1984

recede amid the illegible chaos of disintegration. The mind substitutes metaphors of the known in an imaginative effort to overcome the breakdown of rational cognition, but one cannot describe these images with any precision—they slough off language. Identification fails, and with it identity: in this wasteland entire categories of human functioning collapse into one another as the objects that supported them are obliterated.

With the Howlers Hill pictures, Arnatt succeeds in a kind of indexing of the unintelligible; what the camera registers so accurately, the eye perceives but may not recognize. These pictures are located at the edges of apprehension, in both senses—of an attempt to comprehend, and of anxiety in the face of the unknown and indecipherable.

The Ghost in the Machine
More scenes from English life, in Susan Trangmar's *Untitled Landscapes:* a medieval church, the parking lot of a supermarket, the interior of a museum, a view of tower blocks—a few stops on what might be a guided tour, judging from the ever-present figure that leads the way. Rather like the person pointing in scenic postcards, the figure—a woman—seems to direct our view. How has she determined this itinerary? What might these places mean to her? What difference would it make if one were to meet her in the museum rather than the church? In the supermarket parking lot rather than the zoo? What could one make of her in each instance? Which stories might fit each changing scene, would they add up to a unified impression, a single image? Is she stacking the odds against this?

If she seriously means for me to look at these landscapes, why does she so often interfere with the view? If she is, as one begins to suspect, the photographer, why won't she behave properly, resume that invisible position which allows one to look unhindered, to enter the scene? Personally, I'd gladly do away with her; I commit little murders like this all the time, without even thinking. But the emergence of this insistent figure, which reveals photography's impossible fantasy of invisible, omnipotent seeing, points in fact to a repressed suicide within this fantasy. The flat surface of the photograph can only show me as viewer where I cannot be, never was or can be no longer, where I am nothing. The photograph is a limit, not an extension. Having thus negated the viewer's "presence" in the scenario of landscape, this unknown woman might at least show her face, accede to the order of the portrait. But this is not to be, either; she will not dismantle one fantasy only to comply with an untenable fiction of exchanged glances. What maddens is her refusal either to disappear, to function as absence, or, as presence, to be revealed, available. Trangmar's particular use of the cipher of Woman in *Untitled Landscapes* disrupts the usual rules and roles of representation. Through this resistant usage, the artist confuses and questions photography's subjectivities—the self-contained individual, as traditionally pictured in the portrait;

endgame in Arcadia changes scene, the local dumping ground of Miss Grace's Lane forsaken for Howlers Hill, an extensive landfill site near Coleford in the Forest of Dean. Here plastic rubbish bags stretch for many acres, "glittering like jewels in the landscape" as their surfaces catch the light. For Arnatt, the fascination of such contemporary artifacts as plastic trashbags lies partly in their historical implications: one could not have made pictures of this kind twenty-five or thirty years ago simply because many of the objects and materials did not exist then as part of daily life.

Moving in close on the proliferating debris of consumer society, Arnatt discovers in the Howlers Hill material new emotional registers. The rich colors (browns, blues, reds, golds) and the extravagant draperies of deteriorating plastic recall Venetian and Baroque painting; as these associations come to inform the work, a darker and more decadent atmosphere is evident. The photographer admits to intentionally making these images difficult to read. Seeing exceeds knowing as forms and objects lose the discreteness of their shapes. Phantasmagoric elements enter, as ghostly simulacra, often facelike configurations, appear and

the viewing subject privileged, through the device of perspective, as a cohesive identity, with a right to a clear view, a full explanation; and the photographer as an unseen presence directing the view.

The World is a Fabulous Tale
—told and retold, framed and reframed, repeated and multiplied in its retellings. Is this the same as saying that its ways of telling are multiple, too? Can the ways of telling themselves be retold, the Same Old Stories be made to yield new, and different, ones? In *Divergent Series* Yve Lomax pursues these questions through her deconstructive experimentation with multiple narrative lines and representational space.

Using montage techniques to abut one image against another, to produce the confrontation of frame with frame, Lomax draws attention to the way framing constructs a view and positions the viewer in relation to it. This basic structure points to other structures which can be identified by the viewer—who already frames the work within a series of expectations. Take, for example, the fact that many of the images in Lomax's earlier series *Open Rings and Partial Lines* (1984–85) are grouped in panels of three photographs, framed horizontally: a classical formation which activates expectations of left-to-right reading, chronology, cause and effect—in short, the familiar story structure of narrative, as Subject, Predicate, Object, or Beginning, Middle, End. But within this three-part structure, patterns of pure design and abstraction appear, undermining the perspectival logic of the descriptive photographs; by combining found photographs and newly made ones Lomax disrupts the single dramatic moment, creating cinematic effects of flashback, flash-forward, or jump cut. The sight line—the logic of the look in search of its object—may be played with or against left-to-right reading; its imperative defies the rule of the frame, leaps impossible gaps in pursuit of implausible objects. Engaging the viewer's glance, it multiplies positions of identification within the imagery, splitting subjective response into plural perspectives.

The extended format of *Divergent Series* allows a wide range of issues (including nature vs. culture and the sexual politics of looking) and of moods to enter in. Whether the tenor of the work is humorous or serious, the viewer's role in constructing it is vital. Lomax may be just gaming (to use the title of Jean-François Lyotard's book)—but she always imagines an equal partner, as adept as herself at reorganizing the rules, replaying a set of given possibilities to generate new ones.

A Fiction of Reading
A young woman gazing at a book. A familiar scene: think of Vermeer, of Fragonard. But this young woman looks with plastic, opaque eyes toward a book more than twice her size, containing a text whose title mocks both her sightlessness and the

VERDI YAHOODA, from *The Hidden and to Reveal*

viewer's greedy look, Diderot's *Lettre sur les aveugles* (Letter concerning the blind). Appropriately the picture is entitled *"Perspectiva artificialis."*

Another unknown woman: who is she? Olivier Richon's image shows a replica of a nude sculpture by the Italian artist Canova of Pauline Bonaparte (Napoleon's sister) posing as Venus. A real woman concedes her form to myth, to a simulacrum of male desire. So much for the pursuit of origins. This succession of framings and fakeries, ever more distant from any point of pure origin (problematic at best in Canova's sculpture), typifies the movement of displacement within the *Iconologia* series as a whole. As replica, myth, icon, simulacrum displace the referents for which they supposedly only stood in, reference itself becomes a fiction; the signifiers are set free.

Richon undermines the correspondence between sign and meaning (except at the most superficial level), in an openly rhetorical manner, through an elliptical theater of obsolescent symbols. Writing of this tactic, Michael Newman comments, "Roland Barthes has described the photograph as 'a message without a code': for Richon it is rather a code without a message insofar as his practice is to subvert the model of communication."

One could go into mourning for meaning, lament the loss of the "true" image (really the loss of ourselves as the privileged subjects of its knowledge). Or one could take pleasure here in the sheer allure of the image, its self-proclaimed masquerade, and the free play of allusion to allusion detached from the "real" world, circulating across texts, across framings. This rhetorical stance flaunts a certain dandyism; but it spares us photography's old long-faced expression, its mask as the image of truth.

Retracings

Sue Arrowsmith's imagery is both photographic and autographic, indexical and gestural, for she works largely between photography and painting. Relying on her own self-image, often in a tentative relation with preexisting cultural representations, she explores possible elaborations of the self in the spaces between images, between media.

"Her Familiar Dancing" is one of several images made in 1984 in which Arrowsmith combined photographic emulsion, charcoal, and paint (always black or white, of the commonest household variety) on canvas. In these works a negative of an earlier self-portrait was exposed onto the canvas—sometimes more than once, in order to stain it more deeply. The charcoal drawing and the painting both condition, and are conditioned by, the photographic image; the canvas, absorbing all these processes, mediates their rival possibilities.

In other works gestures are literally photographic, made through the drawing of light. In "One, Two, Three, Nine" (1985), a composite image of nine large contact prints, luminous contours of changing positions of the artist's body are outlined

MARI MAHR, from *A Few Days in Geneva*, 1985

If Community life
is to be Lived at its Best,
the greatest good of
the greatest number
must be considered before
the Desires of the Few.

KAREN KNORR, Desires of the Few, from the series *Gentlemen*, 1981–83

by exposed areas of darkness. In feeling and procedure, this light drawing has parallels with charcoal drawings in which Arrowsmith traces and retraces a succession of contours and movements of her body onto a sheet of paper. In both cases the drawing or outlining which creates an image, an object, is a self-determining movement by the artist: a physical moment of subjectivity.

A notion of dance—of an aesthetic, self-delineating yet fleeting gesture—seems implicit in this work. Shifting outlines, whether photographic, painted, or drawn, suggest the possibility of transformation, of change. This feeling is what marks Arrowsmith's particular coming to terms with representation. If the desire for representation or mirroring is an unavoidable part of the processes of identity, and if a representation is inevitably only a semblance of something displaced, that has escaped, then perhaps it is better this representation should be self-created, maintaining a measure of indeterminacy.

Incognito
Evading identification, continually relocating her own blurred image, Susan Hiller uses the demotic, democratic medium of the photobooth to generate multiple images of self. Subverting

the conventional, reductivist use of this crudest mode of portraiture, she refuses to produce an Official Version: the single image, primarily used on an identity card, that passport by which one accedes to the Order of Things, the Order of the Day. Her time is midnight; place, Baker Street. Underground London, Nighttown, at a crossroads near the center of a vast network of connections, a nodal point exploding into divergent lines: Metropolitan, Bakerloo, Jubilee, Circle. Millions of people in transit everyday, in this night under day.

There are sudden illuminations in subterranean chambers as flashbulbs pop behind the curtains. But the subject turns aside, lowers her head, will not be precisely centered, clearly seen. She rehabilitates those usually censored selves the photobooth spews out, retrieves their plural moments, blows them up to larger-than-life proportions. She tattoos the faces with indecipherable script, unwilling that the spectator should see from the outside a face that she inhabits but does not see from the inside.

Resisting representation, but attesting to the desire for utterance, this script does not assume a singular "I." Hiller draws upon Surrealist traditions of automatic writing which erode

notions of individual authorship. And indeed, she patterns her own movements in these pictures on the evasive gestures she discovered in images other people had made in the photobooths. These shared gestures and indecipherable scripts move toward a more collective sense of identity and propose a language of spontaneity, beyond individual control.

Heartland

How to address questions of orientation, of locating oneself in relation to place; of locating the photographic in relation to communication, to imagination? Over the past few years Hannah Collins has proposed within her work a series of subtly shifting positions with regard to the idea of place—sometimes as a particular geographical location, sometimes in the more generalized sense of a social space. *Evidence in the Streets* (1985) was derived from a specific ground—an area in the east end of London known as London Fields—and a personal perspective, as the artist attempted to locate her relation to this place in which she was living. Aware that her connections were tenuous and incomplete, she avoided a documentary approach which might have constructed an impression of more direct, immediate contact.

Having no long-term history of her own in the area, she discovered in the local library images of wartime damage to buildings in the neighborhood. By printing these wartime documents in large scale, with monochrome tint, she resurrects and distances these images, as if in memory. Without presuming to a full understanding of the history of the neighborhood, Collins was able to recover at least a partial sense of place now largely lost to public consciousness.

Both personal and distanced, *Evidence in the Streets* marked Collins's developing preoccupation with socialized spaces. Since then she has pursued this concern primarily through images of staged interiors, very pared-down settings, presented environmental-size in black and white. The scale of these pictures seems to invite a kind of imaginary entry while making the viewer aware of the unexpected intrusion of the image and its proposed space into another, preexisting space. These works, by setting up confrontations between spaces, implicitly ask viewers to reevaluate their perceptions of both the "represented" space and the actual space, which also embodies a cultural or social *mise-en-scene*. In both instances, it is as if one were intersecting an ongoing narrative: what might the script, the text of this space be? What relations does it privilege or preclude, what modes of imagination does it foster or preempt? What different readings of it might be possible?

The persistence of questions similar to these in the works discussed here links them not only with each other but with current preoccupations with representation, interpretation, and knowledge. In the conflict between an empirical or pragmatic view based in presence and immediacy and one which privileges the role of language and cultural framing as a precondition of knowledge, the status of the photographic image is bound to be a matter of contention, insofar as the photographic, unlike other modes of representation, bears the trace of what it depicts. As the inheritor of what Yve Lomax has called "the power of glimmering visibility," it seems to retain something of the immediacy of direct sensory impressions and through this "aspires to a union of presence and absence." The photographic makes us forget its status as medium—that which comes between—as well as the preconditions of framing, cultural, mechanical, psychological, contextual, that qualify its indexical relations. Yet a normative notion of the photographic as giving unmediated access to the real is precisely what allows the photograph to impart its verifying illusion to fictional or staged events, and the relation of the index also permits the medium to absorb, recombine, and reproduce both its own preexisting images and the imagery of other visual media, reducing all these elements to its own terms in nonreciprocal relations.

As both index and construct, the photographic image provides fruitful if constantly shifting ground within which problems of reading and knowing can be reconsidered at different levels and in changing contexts—its potential relocations would seem to be indeterminate, its epistemologies multiple. The spectrum of possibilities discussed above favors work that critically disrupts reading the image with regard to the more general issue of framing. But other important work to do with framing is also to be found in a British context: Karen Knorr's series *Gentlemen*, which reverses the politics of looking within a critique of British social hierarchies; Helen Chadwick's "One Flesh," which plays off the contemporary medium of xerography against traditional religious imagery reconceived in favor of the feminine. Roberta Graham's huge lightbox images also have implications of the sacred, as she combines painting and drawing techniques with photography to suggest an interiorized perspective of the body. Like Graham, Verdi Yahooda is involved in making visible, using methods of framing and reformatting within photographs of personal and domestic objects to revalue them under a ceremonial aspect. Mari Mahr's series *A Few Days in Geneva* relocates the photographic image in a context of subjective memory and reverie, combining her own photographs with objects or elements of staging that bring performative and sculptural aspects into the rephotographed final images.

As little as three or four years ago, much of this work might have been considered "fringe interference," an intervention between traditions of British documentary and a newer school of highly didactic and theoretical image-text work mostly centered about the Polytechnic of Central London. Now it is becoming increasingly common to discover in group exhibitions a wide spectrum of differing ways of working with photography as a means of exploring the medium's recordative, fictive, and critical capacities.

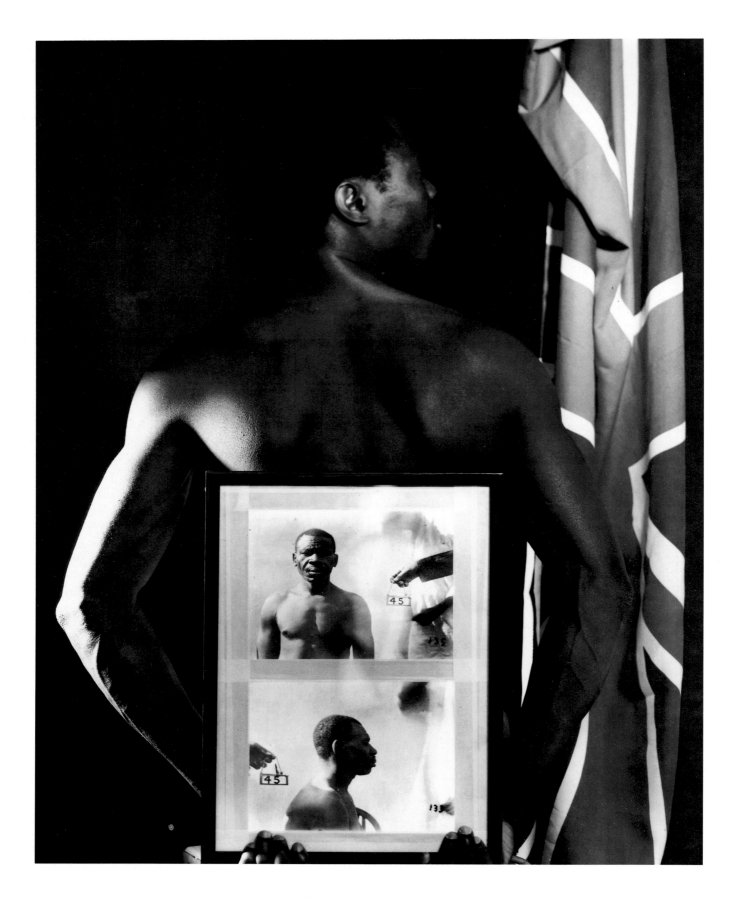

DAVID LEWIS, The Flag of Our Ancestors, 1985

Other Britains, Other Britons

By Gilane Tawadros

Those people who are in Western civilization, who have grown up in it but yet are not completely a part (made to feel and themselves feeling that they are outside) have a unique insight into their society. . . . The black man or woman who is born here and grows up here has something special to contribute to Western civilization. He or she will participate in it, see it from birth, but will never be quite completely in it. What such persons have to say, therefore, will give a new vision, a deeper and stronger insight into both Western civilization and the black people in it.

C. L. R. James, *Ten.8*, 1984

The new vision that characterizes the work of the young Black photographers (using the term to cover not only people of Afro-Caribbean descent but also Asians and people of Middle Eastern origins) in this volume derives from a critical reassessment of the construction of racial difference and identity in contemporary Britain. In recent years, a new generation of Black artists, born or brought up in Britain, have begun to articulate the necessity of bringing their art from the margins into the central cultural arena. The work of many of these photographers takes the form of constructed narratives which weave together threads of history, culture, personal experience, and sociopolitical realities into a tapestry whose central themes are issues of race and representation.

On a technical level the phrase "D-Max"—the name adopted by a group of Black photographers established in Britain in 1987—refers to the maximum density of which a given emulsion is capable; on a symbolic level, the name alludes to the photographers' awareness of the aesthetic and political plurality of Blackness in British society. Since the mid 1950s, when settlers from the West Indies and the Indian subcontinent first arrived in Britain in significant numbers, notions of "Blackness" and "Britishness" as fixed and mutually exclusive categories have been called into question. Blackness has come to be seen by artists and photographers alike as a social and political construction modified by gradations of class, gender, and generation, rather than an unchanging essence or cultural absolute. At the same time the concept of "Britishness" as a single, abiding national identity is seen to contradict the reality of contemporary Britain as a multicultural society with diverse histories, religions, and traditions.

David Lewis, one of the core members of the D-Max group, addresses these issues in his image entitled "The Flag of Our Ancestors" (1985). A Black man, his head barely perceptible within the frame of the image, turns toward a Union Jack standing at his side, while against his back he holds a frame containing a pair of prison-style mug shots. The flag of the title is an ironic reference to the Union Jack and to the idea of a "United Kingdom," with a common political and cultural heritage. The Black man or woman who is born or brought up in Britain experiences the ambivalence of having, on the one hand, a British national identity, and on the other, an ancestry whose history has often been one of enslavement and criminalization under British imperial rule. Nonetheless, the history of Britain and the history of Black people are not separate; instead, as Stuart Hall observed in *Ten.8* magazine in 1984, "Slavery, colonization, and colonialism locked us all into a common, unequal, and uneven history." Furthermore, the frame-within-a-frame in Lewis's picture reminds us of the contradictory nature of representation: on one level, representation in the form of forensic photography is a device used by the state to classify and record what it defines as "criminal," in this case the Black man; on another level, photography is the expressive tool by which the Black photographer can deconstruct levels of racial and national imagery.

In his series *Family Album* (1987), David A. Bailey, another member of the D-Max group, explores several modes of representation, each of which vies for authenticity. Against the background of a "Made in England" clock and a montage of snapshots, a family album is displaced by a Black magazine which in turn is displaced by the screaming headlines of a tabloid newspaper. As the clock ticks on, marking the shifting historical context, the changing assemblages of images address the contradictions between private and public representations of race. The series progresses from innocence to experience as we move from snapshots recording serene personal episodes of family life, to an artificial image of Black family life on the cover of *Ebony* magazine, and finally to the vindictive headlines of the tabloids.

In her *Pastoral Interludes* series Ingrid Pollard—one of two women to exhibit with D-Max initially—explores the conflict between the personal and the political through the very different genre of landscape photography. As a Black woman, Pollard articulates in her images of the Lake District several levels of alienation and Otherness. The Lake District, which in many ways epitomizes the "authentic" British countryside, confirms the status of the Black woman as an outsider. These photographic landscapes recall with irony the tradition of eighteenth-century British landscape painting, which sought to establish the countryside as the natural domain of the British middle classes, as well as the Romantic "Lake Country Poets," for whom the English countryside provided a metaphor of individual freedom and transcendence. But it is from precisely that landscape that Pollard, doubly Other as both Black and female, is excluded. By confronting this idealized Britain with the reality of the Black experience, these images challenge the social and political framework within which such concepts as "naturalness" and "Otherness" are constructed.

While Zarina Bhimji is not associated with the D-Max group,

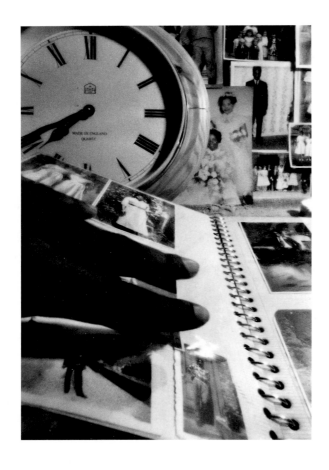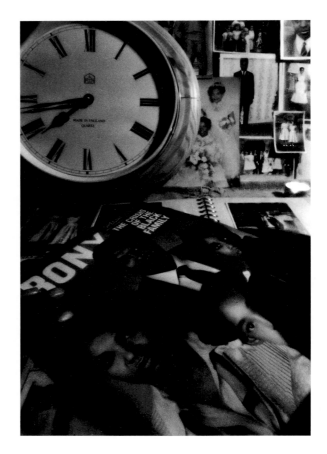

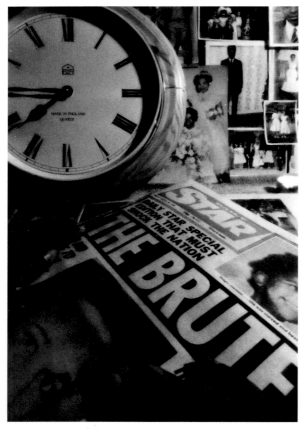

. . . it's as if the Black experience is only lived within
an urban environment. I thought I liked the LAKE DISTRICT,
where I wandered lonely as a BLACK face in a sea of white.
A visit to the countryside is always accompanied by a
feeling of unease, dread.

INGRID POLLARD, from *Pastorale Interlude*, 1987
(*opposite*) DAVID A. BAILEY, from *Family Album*, 1987

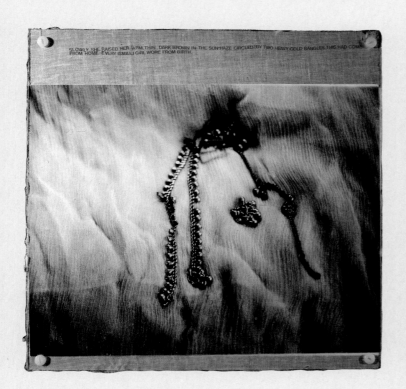

SLOWLY SHE RAISED HER ARM THIN, DARK BROWN IN THE SUN-HAZE CIRCLED BY TWO HEAVY GOLD BANGLES THIS HAD COME FROM HOME—EVERY ISMAILI GIRL WORE FROM BIRTH.

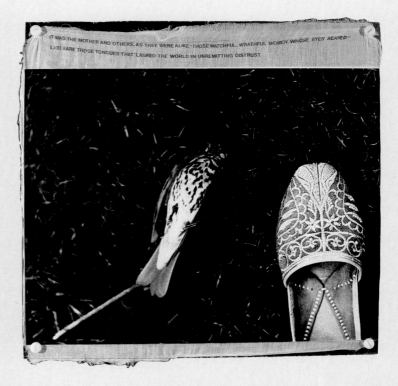

IT WAS THE MOTHER AND OTHERS, AS THEY WERE ALIKE—THOSE WATCHFUL, WRATHFUL WOMEN WHOSE EYES SEARED—LAID BARE THOSE TONGUES THAT LASHED THE WORLD IN UNREMITTING DISTRUST.

ZARINA BHIMJI, She Loved to Breathe—Pure Silence, 1987; from *The Essential Black Art* exhibition, 1988.
(In the installation version of this work, piles of spices are placed in front of each panel.)

44

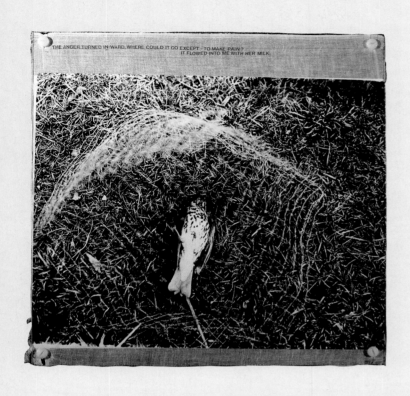

THE ANGER TURNED IN-WARD, WHERE COULD IT GO EXCEPT - TO MAKE PAIN?
IT FLOWED INTO ME WITH HER MILK.

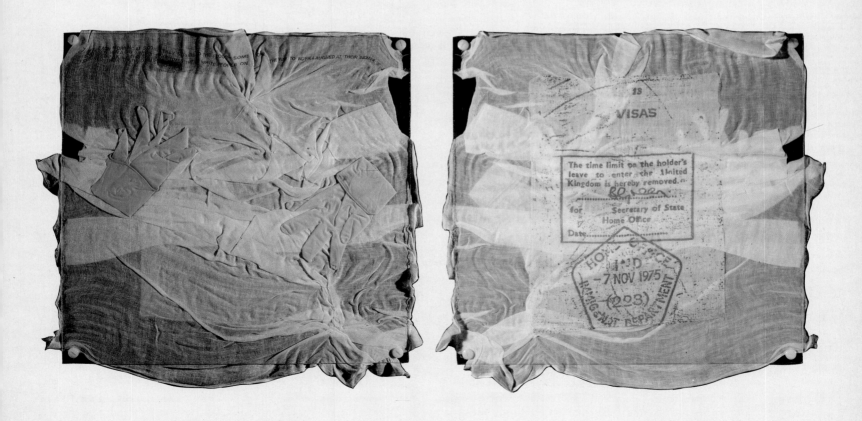

VISAS

The time limit on the holder's
leave to enter the United
Kingdom is hereby removed.

for Secretary of State
 Home Office

Date

HOME OFFICE
I.N.D.
- 7 NOV 1975
(203)
IMMIGRANT DEPARTMENT

her work shares their interest in exploring personal identity within the context of cultural identity and representation. *She'd Love to Breathe—Pure Silence* (1987) is an installation in which intense red and orange colored spices are sprinkled on the floor in front of large panels hanging from the ceiling; the panels, which include photographs and texts, can be read from either side. One panel in the series represents a dead bird and a pair of embroidered slippers. The slippers can be read as a metaphor for an Asian woman, but both the slippers and the bird can also signify migration. Indeed, the experience of migration in all its aspects—flight, identity, social status, nationality—acts as a central metaphorical axis of the installation.

The use of a Home Office visa stamp in one of the final images of the series is a clear reference to the degraded status of Black women (and men) under British law, as well as to the successive pieces of discriminatory legislation that have increasingly limited the rights of entry and citizenship of Black people. But in the face of such bureaucratic and legal harassment, the mounds of brightly colored spices that appear beneath the images attest to the quality and distinctiveness of Asian culture, which resists the oppressive stamp of uniformity that British society and law attempt to impose upon it.

Among all these images, the work of Mitra Tabrizian most explicitly takes the form of constructed narratives. The triptychs in her series "The Blues" enact dramas whose settings and lighting are reminiscent of aspects of film noir. Like movie posters which depict a tense but leading moment, the images invite us to project a story onto the still photograph. These fabricated scenes underline the way in which both words and images construct our identities in everyday life: black is defined in opposition to white; man is constructed in opposition to woman. The images within each triptych undercut these seemingly clearcut distinctions: a Black man appears in a white mask, while a white man's face, reflected in a car mirror, is echoed by the image of a Black man's face in the car's headlights. By compounding and complicating these simplistic but familiar oppositions, these photographs challenge the ways in which culture and society position us and construct our identities.

Black art and politics do not occupy separate spheres. Together, the diverse images here begin to chart the cultural and political terrain in which racial difference and identity are constructed, and represent the first stage of a kind of photographic inventory of the sort described by the Italian writer and activist Antonio Gramsci:

> *The starting point of critical elaboration is the consciousness of what one really is, and is 'knowing thyself' as a product of the historical process to date, which has deposited in you an infinity of traces, without leaving an inventory; therefore it is imperative at the outset to compile such an inventory.*

MITRA TABRIZIAN with ANDY GOLDING, The Blues, 1986–87

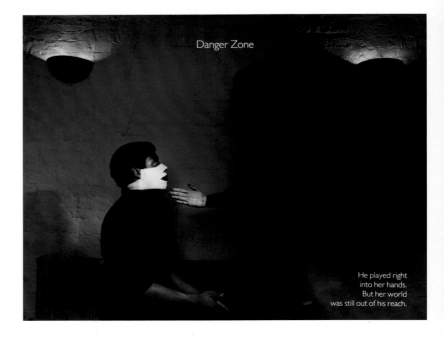

Danger Zone

He played right into her hands. But her world was still out of his reach.

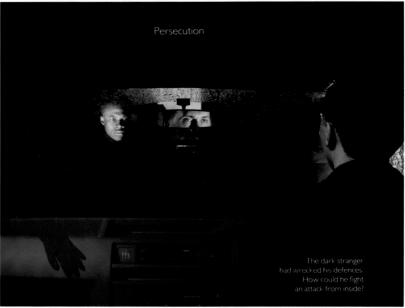

Persecution

The dark stranger had wrecked his defences. How could he fight an attack from inside?

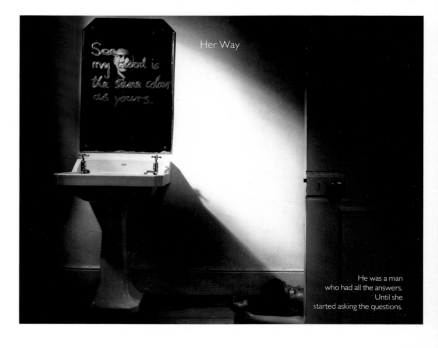

See my blood is the same colour as yours.

Her Way

He was a man who had all the answers. Until she started asking the questions.

Through the Looking Glass, Darkly

By Rosetta Brooks

The era of mass consumerism in Britain was born after the Second World War, in a heady atmosphere in which optimism was combined with a desire to start anew and a yearning for order after the chaos of the war years. At that time England took her lead from her prodigal son, America, acknowledging, for perhaps the first time in her history, that her preeminence as an economic and political force had come to an end. The British found themselves in a new era, a whole new ball game with different ground rules, in which England was just one country among many who were trying to start afresh after the devastation of the war.

Postwar consumerism reached its height in Britain in the '60s, when attempts to americanize the culture achieved their greatest strength. Nowhere were these efforts more apparent than in the idealized images, depicting the better life that a consumerist Britain would supposedly partake in, that saturated the media in that era. Mass culture, mass communications, mass production: the very terms suggest quantity, the mainstream majority, sameness rather than difference, the undifferentiated crowd. All of these qualities, though, were antithetical to traditional British culture, which had always been characterized by its emphasis on individualism, even eccentricity. If, in the 1930s, the mass media in Britain and elsewhere had often represented the crowd as a frightening force, in the '60s the crowd was shown as unified, harmonious—Coca Cola's giant singing family.

Yet alongside this idyllic picture of the benefits of sameness was the image of the corporation. The belief in technological progress that provided an important underpinning for the ideology of consumerism was embodied publicly in monumental images of corporate power. The huge screens and giant billboards that changed the landscape of Britain so dramatically in those years seemed to suggest that the future would be, if nothing else, big—outsized, to match the scale of the corporate agents of the new consumerism.

Some of the most powerful and effective representations of the utopianism of the era were the logos devised by the major movie companies. Although it originated earlier, MGM's roaring lion took on a new symbolic force in Britain after the war. It could be seen as a metaphor for the effects of film itself: the medium roars, and our senses are saturated. More than a corporate stamp of identity, the MGM logo became a powerful symbol of media imperialism. Postwar Britain, with its widespread desire for strong leadership and a sense of direction, freely acceded to the media's claims to sovereignty as symbolized by MGM's roaring lion.

But by the 1970s it became apparent that the unifying culture machine which had seemed so powerful and attractive in the '60s had begun to sputter badly, as economic depression in England exposed the falseness of these imported images of innocence and unity. Cutbacks in education and jobs, in housing and health care, disrupted the mainstream consensus in England—if, indeed, one had ever really existed. The breakdown of the consumer culture that had been the hallmark of the '60s now reinforced the feeling that British culture had always been—and remained still—a culture of ghettoes, of islands within the larger island. These autonomous and mutually exclusive entities had no desire to be absorbed into the kind of mainstream identity that is central to American culture.

If anything, the transgression of any mainstream has long been characteristic of English culture, which has always been obsessively, even masochistically, eager to explore the margins of life, more interested in the detail than the whole. The spectacular openness that was both the promise and the demand of consumer culture contradicted the British passion for assembling a psychological map out of cultural fragments, for seeing the world not as a simple, homogeneous whole but as a complex series of close-up views, made from different perspectives. The sense of openness and innocent optimism that had accompanied the consumer paradises of the '60s had denied the British their accustomed opportunity of turning to the marginal underworld and the subversive underside of culture for social meaning, and had prevented them from exploring the dark myths that lurked beneath the superficial gloss of appearances.

By the 1970s, media images had begun to emphasize the disjunctive elements of culture, the pieces that didn't quite fit, rather than the cloying, all-embracing unity of consumer culture. In opposition to the happy-face images purveyed by the mass-culture machinery, streetwise subcults now proclaimed a threatening shadow-world in which subversion and consumerism were linked. Skinheads, poseurs, and punks all served as evidence of the growing sense of alienation many felt from the illusions of homogeneity offered by mainstream culture.

In fashion terms, punk clothing, with its torn T shirts and tattered tights, its red eye-makeup and black lip gloss, provided a graphic representation of youth's estrangement from conventional images of sexual allure. With typically British, tongue-in-cheek cynicism, punk clothing appropriated the most socially transgressive garments of pornography and deviance, taking them out of the secret recesses of the psychosexual closet and parading them through the streets. Lifted from the contexts of the nursery, the deviant's closet, and the sex shop, these clothes—with their safety pins and suspender belts, leather and vinyl wear—joyfully proclaimed a disruptive violation of traditional fashion symbolism. Like elements in a collage, the fashion images that were combined in punk style produced a conflict between the disparate social codes they represented; wearing these clothes became a strategy for breaking through social boundaries.

YVE LOMAX, from *Divergent Series (The World is a Fabulous Tale)*, 1988

SUSAN TRANGMAR, from *Untitled Landscapes*, 1986

JOHN HILLIARD, East/West, 1986

As more and more images with deliberately ambiguous social meaning have appeared throughout the '80s, attempts to awaken a sense of cultural centrism in England seem finally to have been laid to rest. The optimistic, "brand new" world of consumerism opened up by the media in the '60s has now been left behind. Once again England has embraced the richness of cultural fragmentation, rather than the indifference of cultural unity. Consumerism's open panopticon had become a Piranesian prison for a culture whose strength of vision has always been maintained by its askew, off-center quality. Splintered by the economic rigors of recession, the British sensibility has found a new unity in variety and difference rather than sameness and uniformity.

Britain in the 1980s has become a society in which the idea of the mainstream has given way to a potentially infinite number of social spaces in which small groups, and even individuals, can act out their interests in collective isolation. In doing so, British society is following the model not only of immigrant groups, forced by legal and social constraints into physical and cultural ghettos, but also of the art world, which in modern times has always been relegated to the periphery of society. By remaining outside of accepted class hierarchies, artists have gained a measure of freedom, but by the same token they have been shunted into a marginal cultural role, unknown outside their own community except as fictionalized mass-media celebrities.

Perhaps in response to this societal breakup, many British photographers and other artists have dealt with issues of identity and community in their work. John Hilliard, for example, frequently butts together positive and negative versions of the same picture in his large photoworks, setting up tense pictorial equations that suggest questions of mirroring and image replication.

But in these twinned constructions Hilliard often uses images of non-Western people, thereby extending their implications to questions of personal and social identity, of Self and Other, as embodied in the mirror worlds of disparate cultures.

Susan Trangmar and Yve Lomax address similar questions of identity and representation in their work. In Trangmar's series *Untitled Landscapes*, a mysterious figure appears in various typically British settings—in front of a church, say, or outside a factory. But in each case the figure is only an observer, not involved in the scene in other ways; she (and by extension everyone) has become a kind of tourist within her own culture. For their part, Lomax's multipaneled photoworks, made up of disparate images juxtaposed into rebuslike visual constructions, suggest the possibility of discovering other sorts of meaning by placing images together. In the end, though, the pictures remain elusive, fragmented, suggestive rather than definite.

Although social fragmentation of this sort seems especially prevalent in British culture, it is by no means limited to it. Beneath the tissue of uniformity provided by electronic media and information technology, cultures around the world are breaking up into collections of parallel but diverse social groups based not only on such familiar categories as class and race, but also on common interests or desires—even on shared tastes in fashion or art. Increasingly throughout the world there no longer seems to be an all-encompassing, mainstream culture. Instead there is a growing sense of otherworldliness to our world. And it is just such a sense, of occupying an other-world reminiscent of the distorting-mirror world of Lewis Carroll's *Through the Looking Glass,* that has invariably exerted a fascination over the British imagination.

JOHN HILLIARD, Sixty-Nine, 1986

Romances of Decay, Elegies for the Future

By David Mellor

Great Britain: Disaster Zone[1]

Some sublime catastrophe, which has undone the Pastoral as a mode of representation, is to be found across much of contemporary British photography. To examine contemporary British culture in all its phosphorescent horror entails some understanding of this particular trope, this organizing category and force—the trope of catastrophe. To look into these pictures is to look upon dystopias: sometimes debris dis-figured; sometimes pristine, modernized. Varieties of the Pastoral have long circulated as the dominant rhetoric of British photography and a larger British culture, whether documentary or no; and yet, at moments of historical fracture in this century, the phantasized unity of British subject (in all its senses) and scene, of British body and land, has been broken and polluted.

In the perspective of the long duration and the big stories of genre and of history, to look upon, for instance, the imaginary landscape of Tim Head's "Toxic Lagoon" is to see a colorized, migraine version of another Fall; that is, to recall Paul Nash's First World War mustard-gas landscapes of heaped-up defilement, which acted as injured negations of the Pastoral and birthmarks of the transition from Edwardian and Georgian culture to the culture of the postliberal state. (Much of the most significant art in twentieth-century Britain has been in this Anti-Pastoral mode: Walter Sickert, Francis Bacon, Eduardo Paolozzi). In their allegories of catastrophe these artists (Nash then; Head now) are negotiating the catastrophes not only of history and the future—*We Are Making a New World*[2]—but also the crises of subjectivity.

Crisis? What Crisis?[3]

And what sorts of catastrophe do we speak of? What is being troped here? We should remember that there has just been a profound restructuring of British culture. The last nine years of Conservative government, with their accelerated economic and social changes, have been a period of—to use the word exactly—catastrophic change. One paradigm of Britishness has been uprooted for another; a great alteration has taken place, and a vision of a rationalized, electronicized, and purified postindustrial-Britain-as-Pastoral has been embraced. To this end, fixities of class, employment, industry, and the state have been unfixed by a program of forced modernization and the unleashing of an unbounded consumer culture. It is to this zone of Tory Futurism that Anna Fox, Paul Reas, and Andy Wiener accord attention.

The trauma of the recent transition from Welfare State to the polity of Popular Capitalism may have found its tropes in representations of those excluded portions of decay and waste which are the obverse side of the newly reconstituted Pastoral of the Enterprise Culture. In this way loss, abjection, and the ruination of popular memory are themes that recur across a range of media: for example, in the detritus of plastic goods composing a derelict Britain in Tony Cragg's sculpture, "Britain Seen from the North" (1981); in the rages of Howard Barker and Steve Berkoff's plays; or, most conspicuously, in films such as Hanif Kureishi's and Stephen Frear's *Sammy and Rosie Get Laid* (1987) and Derek Jarman's *The Last of England* (1987). In all these works, "Britain" as an entity is invoked, but the demoralizing disclosure is of Britain as a fallen, lapsarian site, a land of abominations.[4]

It is the disclosure of this hysterically dejected Britain that preoccupies the high emotionalism of some of the photographers gathered here, including the Scots, Matthew Dalziel and Ron O'Donnell. Even the lapidary, politically correct tableaux of such conceptually oriented photographers as Olivier Richon, Mitra Tabrizian, and Jo Spence have, over the past five years, suffered a meltdown into melodrama and violent color. But the trope of catastrophe may not be engendered solely by historical circumstance. Instead the catastrophe may be gender itself—as Spence, in particular, has shown. Disaster may in fact be curled up in the recesses of sexuality and representation, as in the photographs of Peter Fraser and Calum Colvin.

The Grave's a Fine and Private Place

To be a (male) child growing up in the 1950s and '60s in Britain meant to have an inevitable familiarity with the space-pilot hero of the *Eagle* comic, Dan Dare. He has been remembered by Calum Colvin in his "Cenotaph" (1988), disinterred and reinterred in a sepulcher-temple seemingly designed by some miniaturized Albert Speer for the Bay City Rollers and their early-'70s "Tartan Army" agglomerate of Scottish kitsch.

But Dan Dare is only one of the male questers to this shrine of seeing sexual difference, along with a kilted Scottish Action-Man doll. Colvin's "Cenotaph" offers us and the pilgrims within it a triptych of peeps, closer views, and then serious unsettlings of gender that mock a daring male "explorer of space." For the spectator's gaze travels down the concrete-block columbarium, conveyed by the accessories of seeing—mirrors, crystal glasses, lamps to illuminate—to a paranoiac-critical[5] version of Michelangelo's "Dying Slave," whose torso is painted across a guitar and whose crotch and legs are mimed by a painted plaster statuette of the Venus de Milo.

Superimposed like this, double images of sexual difference arise, reinforced by the nearby Madonnas and Scots pipers: satellite, framed pictures of cultural stereotypes of maleness and femaleness. But these images are dissimulated in the uncanny righthand panel of the triptych, where the components of the male "Slave" are separated—the guitar, placed out of context, toppling spatially—and the statuette of Venus is asserted. Colvin performs an autocritique of his anamorphic constructions with the result that the composite male (already sexually ambiguous) is dissolved, and desire—and our point of view—are recycled, taken back to the threshold. The kilted Scots doll ends his quest, solves the enigma,

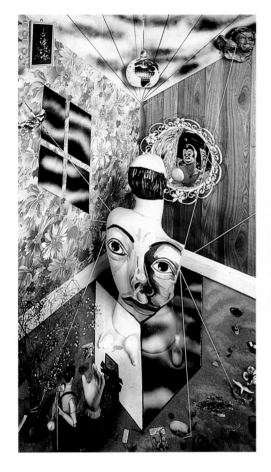

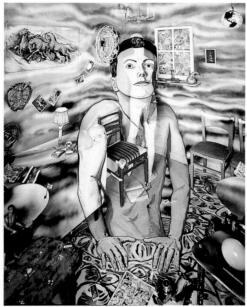

CALUM COLVIN, The Garden of
Earthly Delights, 1987

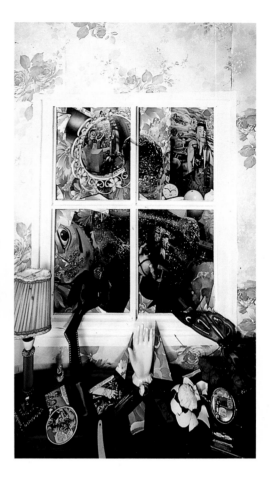

and discovers castration, horror, and lack
... and thus, Narcissus-like, turns his
gaze to a convex mirror.

Here catastrophe takes the form of a
gendered event—it is *male* catastrophe
that Colvin models and narrates. These
Cabinets of Fetishes compress "master-
pieces" and legends of a collapsing
Western culture; elsewhere Colvin has
anamorphosed Botticelli, while other
gods and figures of mastery, such as At-
las, are scaled down and ironized, like
comic versions of the gods from some
Offenbach operetta, or are contaminated
by the profane, lost and lacking, excre-
mental world of the plastic Action-Man.

An Evening of Scottish Rubbish
The twilight of social documentary and
the impossibility of the revived, eman-
cipatory project of documentary realism
that was a commonplace of '70s pho-
tography in Britain was the point of de-
parture for Ron O'Donnell. The Second

Cold War, at its height in the early '80s,
together with the stifling nemesis of
Chernobyl—further generators of the
trope of catastrophe and of the End of
the World—provide an essential context
for his tableaux. In his photographs the
topic of nuclear annihilation vies with
that of terminal decay through the social
entropy of Popular Capitalism. It is an
unstable, ludicrous, comic terror that
speaks here, declaring itself as a series of
grisly jokes delivered with gusto: given
the chance, O'Donnell would probably
present Ragnorak, the Nordic myth of
the destruction of the universe through
fire, as if it were a one-liner from Scottish
comedian Gerry Sadovitch's scrofulous
stage act.

And a kind of domestic Ragnorak is
O'Donnell's constant reference. His in-
teriors are burnt-out, crammed with fur-
niture which has been badly singed, re-
covering some semblance of sooty
authenticity against the cartoon-bright,

polychrome array of consumer goods
that, in "The Great Divide" (1987), are
set up in opposition to it: the divide, gro-
tesquely overdrawn, between a darkling,
impoverished Scotland and an inanely
affluent Southern England. In this mel-
odrama of possessions, O'Donnell's
"Tonight's Star Prize" (1987) takes his
constellation of metaphors of burnout
and domestic-scaled apocalypse for a
spiraling rocket ride. It is a show in a
room, a display once more. A homely,
cartoon-comic curtain frames a Cruise
missile and a radioactively glowing pile
of fallen autumn leaves. More inert than
the dead leaves, the curtain, room, and
rocket are built from Scottish pound
notes: a circuit of expenditure and waste
extends mordantly through the scene.

The Bars of the Zoo
The ruination and fraying of surfaces, al-
lowing them to open up to indices of their
own history, stands at the center of much

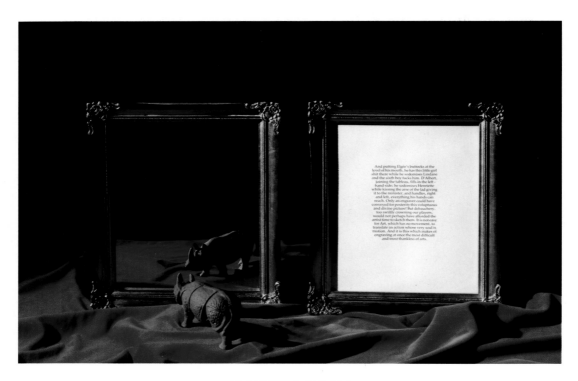

RHETORICA

STILL LIFE
WITH THE EXHIBITION OF A RHINOCEROS

Ile Rousseau, 1789

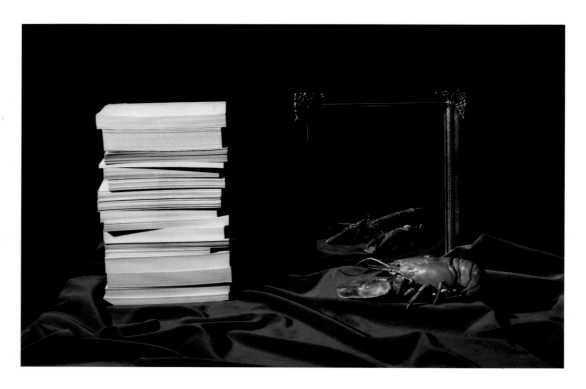

ETHICE

STILL LIFE
WITH THE PROTESTANT ETHIC OF BOOK KEEPING

Ile Rousseau, 1987

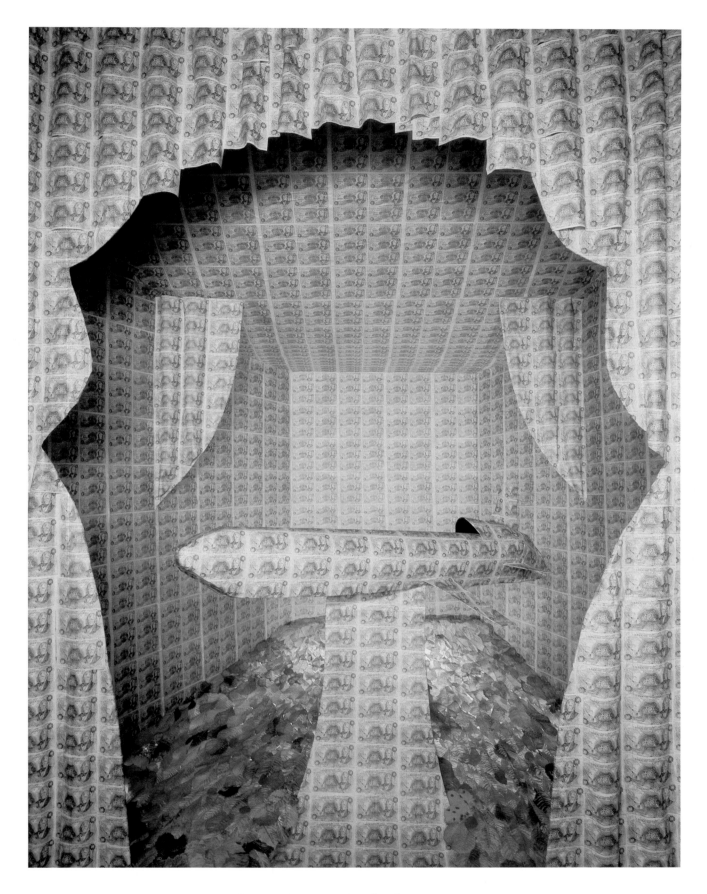

RON O'DONNELL, Tonight's Star Prize, 1987

(*opposite*) OLIVIER RICHON, Ethice/Rhetorica, from *Iconologia*, 1987

55

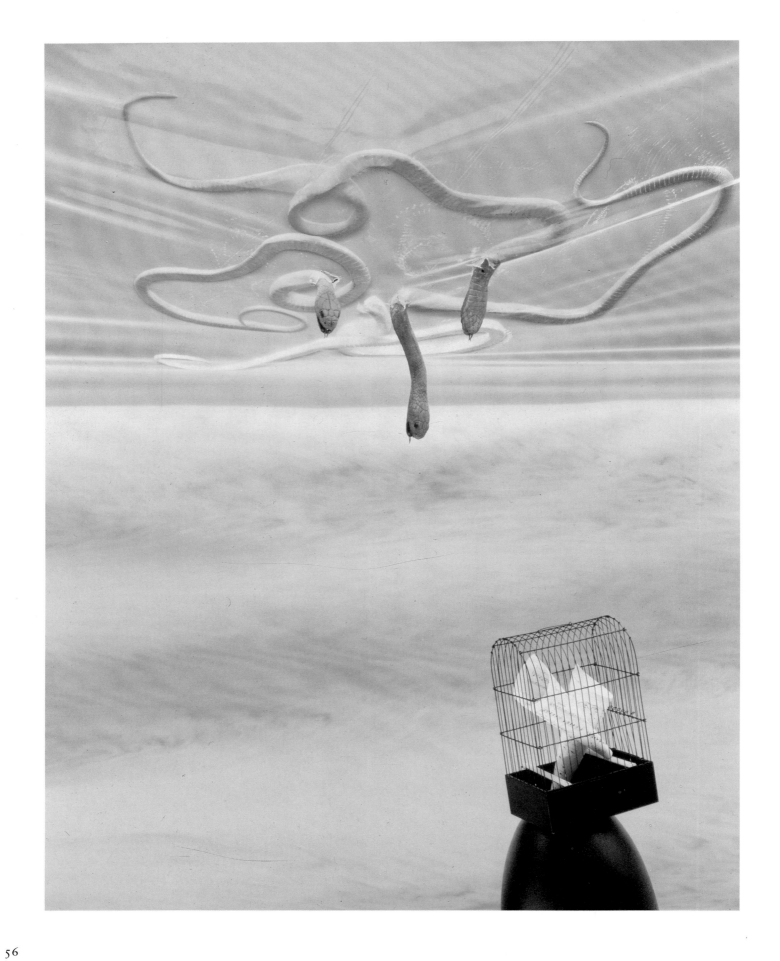

contemporary British art, such as that of the Boyle Family, with their sculptures of weathered pavements and demolished tiled hallways. O'Donnell's "The Antechamber of Rameses IV in the Valley of the Kings" (1986) shows the breaking through, in a derelict Scots parlor, of another, more archaic order from ancient Egypt. This historical Sublime which irrupts into the worn-out, banalized present finds its parallel in the kind of Natural-History Sublime active in the photographs of Boyd Webb. Here the incommensurable descends from the realm of air or water; the agents in his cosmic vistas are never dejected or defiled as they are in Head's more overtly ominous landscapes. But they are just as grotesque and sometimes more lethal than Head's poisoned panoramas—such sublime, gigantic mammals as whales or elephants are juxtaposed with the puny works of man, or even with man himself. These leviathans of otherness suckle or threaten the minutely human at frayed points of contact, where the restraining ropes seem about to give way, circular saws to cut through, the sea to engulf him. The possibility of catastrophe, natural or otherwise, lies all around.

But Webb has constructed this supersensible world as a tableau, like O'Donnell's and Colvin's, declaring its own theatrical fictiveness, with its own scrim and minimal backdrop. Unaccountable, inexplicable, absurd scenarios: the vipers have pierced the transparent skin of the sky and downwards they menace the precariously balanced birdcage. Here are flimsy barriers, uneasy equilibriums, and a Sadian nature which overwhelms all things under the studio sun.

History, to the Defeated

But the apocalyptic—*vide* Derrida—is itself a conservative genre.[6] The measure of the melancholia of some of these British photographers is perhaps also a sign of the end of a certain kind of British history and the closure of its future. In the face of the end of history, an exemption might be sought by inhabiting some transcendental place. But in the horrific

ADAM FUSS, Untitled, 1988

(*opposite*) BOYD WEBB, Siren, 1988

vista of Head's "Toxic Lagoon," the excrement still piles up in the Equatorial Belt of Jupiter, this disaster zone full of fascinating, irradiated, and nauseous amorphous rejects. They, the unspeakable, still cling like mire . . . even out here, even in space.

The Dolorous Blow

It is as if all things had been miniaturized, contained, ironized by model- and toy-makers—Colvin's dramas of sexuality and sight rehearsed in corner cabinets; O'Donnell's decayed civic universe tattered in a condemned Edinburgh house;

the wonders and horror of the animal kingdom, staged by Webb; Head's interplanetary space-junk on a tabletop. Peter Fraser eludes such overdetermining strategies of closure and containment by tableaux in his out-of-doors prospects. Yet things are still intimate, they lock together, and something still oppresses in his nighttime discoveries of impacted meetings. At dusk, in the rusty, disconsolate railway sidings at Mountain Ash in South Wales, a pair of freight car buffers cleave together, kinetically fused, yet divided along the line of their contact. Fraser's vignettes are cut and contra-

TIM HEAD, Toxic Lagoon, 1987

dicted, Signs of the Cross with the joins, rust, and screwheads still showing. His transcendentalism can never achieve its goal, because the marks of the profane world will always pull down the objects' flight into the heaven of Symbolism. No failure, this; on the contrary, his prefigurations are perversely Sublime. His junctions, splits, denials, deleted insignias, and faded signs are scars on a male subjectivity, places of intense anxiety and associations of childhood loss.[7] Once more the catastrophe is no recent socioeconomic one; the disaster occurred long ago, in infancy.

While artists like Susan Gamble and Michael Wenyon (or, in a different way, Adam Füss) confer a denatured technoformalism on products, Fraser lends them *stimmung*, pathos. Again at night on the margins of the transport systems, this time on the "Outskirts, Hirwaen" (1985), Fraser is searching in the motorway car parks, between high-sided lorries; a pilgrim, like the kilted Action-Man of Colvin, Fraser has photographed the ancient way to Glastonbury. Here between the juggernauts of Dunlop, the numinous is

only a vestige of the passage into hyperspace mimicked by the blast of electronic flash on the steep-perspective sides of the lorries. We are somewhere in interstellar space, between two touching nebulas; the stars are suddenly illuminated rivets, and beyond is a gulf as dark as the abyss in Jackson Pollock's "The Deep" (1953). (Here again is Fraser's iconography of the dolorous junction, the cut.) Fraser's perspectives open onto some ominous, antipastoral Unknown Region, the photographic equivalent of Vaughan William's lyric nihilism in *Symphonia Antarctica* (1953), a muical narrative about the extinction of the heroics of male-Britishness amid blank, subzero spaces. In the lorry park at Hirwaen, the ice-blue cold clamps down.

In the Enterprise Zone

If these are the last days of documentary, then a voluptuous[8] electric color is alleged to be giving the kiss of life to the genre, galvanizing its ailing body. Mor-

alization and pathos reappear, now recoded as color-satire amid the pristine scenes of service industries and consumption depicted in the photographs of Anna Fox and Paul Reas. Here no surfaces are weathered and broken as a more general token of ruination, for such demoralization is unthinkable—it has been deported beyond the pastel boundaries of the Enterprise Zone. Fox's pictures show a supernormative, high-achieving universe inside that perimeter, a service world of startling, bright transparency which is the new industrial scene. Like John Davies's, hers is an exercise in surveillance of the sites of industry. (But Davies's clarity is only a function of an uncanny afterglow lighting a pacified and colonized once-industrial landscape.) The catastrophe in this case is the happy fall of the reorganization of British industry: to labor in the fields of these electronic workstations, amid these vivid, high-tech Pastorals of bureaucracy. If these are ironic reportage photographs, their satirical tactics uncover as much about the logic of bureaucratic industrialism and the apportioning of regimes of authority

and gender roles as do Victor Burgin's didactic 1985–86 tableau-meditations based on Edward Hopper's 1943 painting "Office at Night." Distracted, frenetic, and swinish, the office workers and executives are engaged in a Hobbesian war of all-against-all: between the heads of a Hire Manager and an Account Manager, there floats on colored balloons a half-colored (lips, jacket) Warholesque icon of the Prime Minister, Patroness of Competition, the individual, and Enterprise.

Blood at the Triumph of Consumption
In Reas's work, too, this saturated, meaningless color luxuriantly collects like the chemical cocktails in Head's "Toxic Lagoon," escaping signification except as a sign of overaccumulation and excess, preparatory to some apocalyptic burnoff. Like Martin Parr, Reas has a predilection for red, especially in the supermarket, where it explodes his grabbed photographs, blasting and repelling the spectator,[9] blowing away any residues of formalism. Reas's book *I Can Help* (1988) takes the form of a journey of lost souls

through the receiving circuits of consumption, from supermarket through shopping mall and garden center, and finally to a new, uninhabited housing estate. Just as Walker Evans began *American Photographs* (1938) with a picture of a child gazing upon the world, so Reas takes the established topic of a babe's innocence and then follows the infant into the temples of consumption, the supermarket and shopping mall. This is the schooling of the young consumer; but it is not sentimental, since the child is already corrupt, carnal, cast next to the bloody meat of other animals or induced into gun-culture by his father. And then comes the infant, standing against a red pillar with a transparent bag over its head . . . a pocket of Grand Guignol which terminates on the next page with the baby propped in the shopping cart, again before a wall of red. But now it is a simulated child, a "lifelike" rubber baby. This infant and the dreaming but determined adults are depowered as they float inside the belly of the leviathan of con-

sumption, elements in another scenario (with curious echoes of Webb) of perverse sublimity in a promotional culture.

The Additive Body
More satirical tattoos of consumption are inscribed on the bodies and surroundings of the couples posed in Andy Wiener's photographs. The model consumers are built up from an exhausted universe of clichés, misrecognizing each other from the identity cards they wear—pinup postcards of Madonna and Stallone. A specular dictionary of clichés, roles, and insignias has been assembled: he is garbed in ex-British Army combat vest and camouflage webbing, she in a white lace teddy; together they are surrounded by emblematic products which slip into slang terminology of maleness (beefsteak) and femaleness (crumpets). Between the lovers' bodies is a promissory packet of "Paradise Slices," laid out on that other cliché of the erotic encounter, the leopard-skin rug—while the heat of desire is provided by a '30s electric fire with both bars on. This comic inventory of the body and desire, in "Sex Scenes No. 1"

PETER FRASER, detail from the triptych Series 1, from *Towards An Absolute Zero*, 1986
(opposite) PETER FRASER, Hirwaen, from *The Valleys Project*, 1985

(1987), rests on the strangeness of commodity fetishism. As spectators, we peer into this steep little tableau of lovers (intertextual with Colvin's version of Botticelli's "Mars and Venus"), the strangeness of which finally devolves upon the oversize mask faces of the couple: their monstrousness is an affront to seeing.

A Final Turning Off

The skies darken behind the supermarkets and the Docklands Enterprise Zone presented by Fox and Reas. A tempest may be loosened in the land of the new Pastoral of Consumption. Mark the Anti-Pastorals on the way, particularly Keith Arnatt's travesties of such genteel Victorian landscapes as Benjamin Leaders's "February Filldyke" (1880). Waste has spilled from the black garbage bag and the land is defiled with its abject contents. Arnatt began his career as a Photo-Conceptualist at the end of the '60s, with a piece entitled "Self Burial"—which was literally just that, with the artist comically vanishing into the earth, an auto-humation for the stigmatized body of the artist, set apart. That was a jokey, fictional memorial; the pictures in Matthew Dalziel's series *Images for Hugh* are intended as an actual memorial, for a friend whose death had been caused primarily by industrial poisoning. However, these somber photographs offer a final, over-arching figure of terminal closure and the abject, which in its implications reaches beyond the personal. A slow, vegetal death drive bursts another plastic bag, this one containing a blackened banana; milk sours and curdles in a bottle against an oxblood painted wall. Dalziel's shallow-spaced, distressed scenes of industrial dereliction are diagnostic, memorials not just to the dead Hugh of the series' title, but also to the generic death of industrial labor that has, in these pictures, hung up its protective mask and turned off the power. The melancholia in these and other pictures is a work of mourning for a fading civilization, for Industrial Britain. Is this not a plague-ridden land?[10]

That it might seem so is a testimony to the persuasive black romanticism of this emotionalist strand in contemporary British photography. The rhetoric of Jeremiah has weighed and judged the City

Strength, stamina and precision had kept him at the top.
Business 1987

There is nothing wrong with avarice as a motive, as long as it doesn't lead to dishonest or anti-social conduct.
Business 1986

It is a moment you planned for, searched for . . . struggled for . . . a long awaited moment of success. Advertisement

Computer taskmasters (can) record every item of work completed, along with every mistake, rest break and deviation from standard practice. Financial Times *1/10/87*

of London short-termers, the mutes and orphans of the hypermarkets; it has wept at the abandoned places of manual labor. But what is represented here is a parade of established social phobias: catastrophic consumerism, pestilential allegories of AIDS, a dis-united kingdom, an irrevocable sexual atomism. All are apt themes for a tendency that at times recapitulates the portentous promotionalism of neo-expressionist painting, while also rehandling the "no-future" slogans of a decade ago.

Like the rainbow, though, the privatized report of apocalypse comes and goes across the landscape of abrupt social change. The best work here points beyond the postures of dejection to something that might come after. Working through the tropes of loss, a number of these photographers seem to be following a strategy of voiding, of emptying out. The resulting pictures are less vivid, less weltered, and less terminal—an art in cloistered beginnings for other, future histories.

[1]Headline in *The Guardian,* June 15, 1988, p. 21. [2]The title of Paul Nash's painting of 1917, Imperial War Museum, London. [3]Headline in *The Daily Mail* in January, 1979, during the "Winter of Discontent" that preceded the Conservative electoral victory. [4]I am indebted here, as at many other points in these notes, to the arguments of Julia Kristeva, and especially to her elaboration of the concept of "abjection" and its consequences in *Powers of Horror, An Essay on Abjection* (1982). [5]To use Salvador Dali's term for his double images of the 1930s, such as *The Invisible Man* (1930). [6]Jacques Derrida, *D'un Ton Apocalyptique Adopte Naguere en Philosophe* (Paris, 1983). [7]"I Hate Green," interview by Susan Butler with Peter Fraser, in *Mike Berry/Peter Fraser/ Francesca Odell/Roger Tiley,* Ffotogallery, Cardiff, 1986, especially p. 24: "In the distance, every now and again, I could hear what sounded like Alsatians barking and my heart was in my mouth. . . . With the flash ready on the camera, I saw the side of an old lorry and I was very forcibly struck by the writing on the side which read 'The Family,' but the 'F' of the word . . . is so faded it is difficult to make out. That had very strong connotations for me, because it was in South Wales that my parents' marriage broke up." [8]The word Max Kozloff used in describing Paul Graham's photographs of Social Security Offices, in "Photography, Text and Art in the Eighties," *National Aperture 3/88,* 1988, unpaginated. [9]My argument here is taken from Michael Fried, *Writing, Disfigurement, Representation* (Chicago: University of Chicago Press, 1987), p. 72. [10]Cf. the playwright Steve Berkoff's recent production of his own play *Greek* in London. It was reported as a "plague-ridden vision of Britain . . . this sceptic isle"; Michael Billington, "Rot of Ages," *The Guardian,* July 1988, p. 28.

63

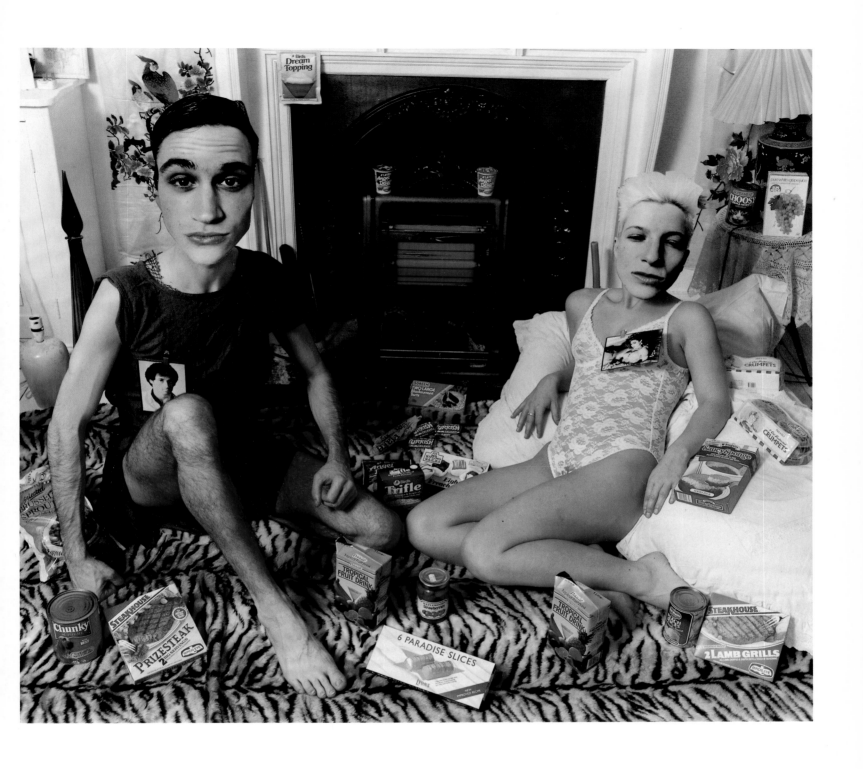

ANDY WIENER, Sex Scenes No. 1, 1987
(*opposite*) PAUL REAS, (*top*) Bank Holiday Monday, Retail Park, (*bottom*) Rubber Baby B&Q, both 1985

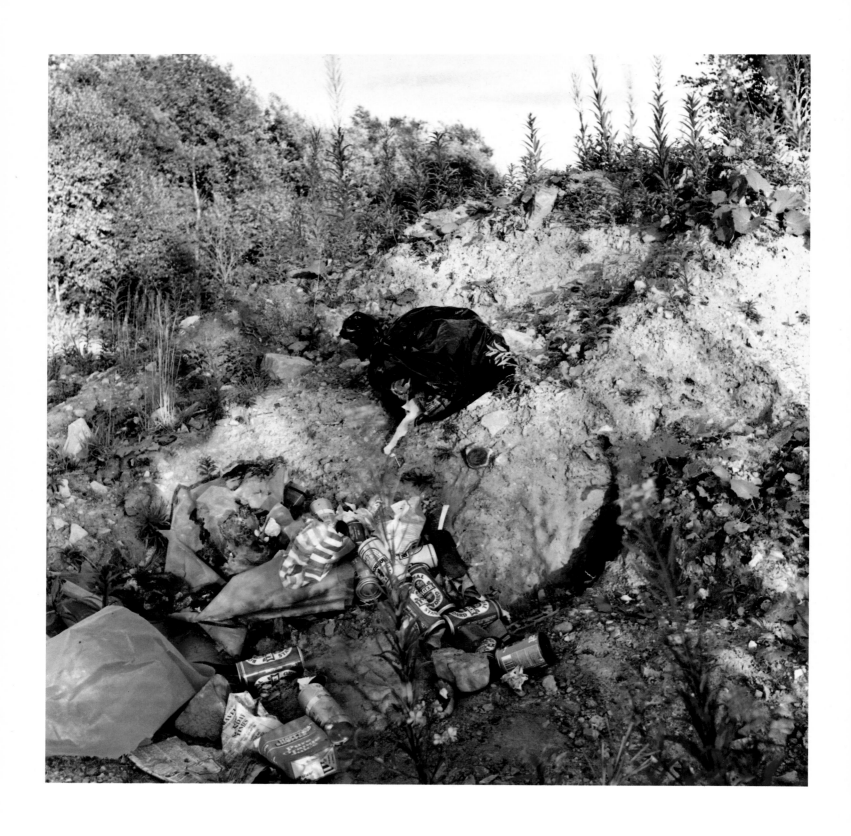

KEITH ARNATT, from *Miss Grace's Lane*, 1986–87
(opposite) MATTHEW DALZIEL, from *Images for Hugh*, 1987

People and Ideas

THE B MOVIE PHENOMENON: BRITISH CINEMA TODAY
By Michael O'Pray

The recent media hype about "the New British Cinema" has been enormous. Since Colin Welland's cry of "The British are coming!" while collecting the Oscar for *Chariots of Fire* in 1982, we seem to have been witnessing a renaissance in British cinema after the doldrums of the 1960s and '70s. In a recent interview, Peter Wollen made a thought-provoking comment on this upsurge: "One of the strengths of what has been happening in Britain is the possibility of a lot of B movies which have done well. *Letter to Brezhnev* is a B movie, so is *My Beautiful Laundrette,* Derek Jarman's films are B movies . . . these small, low-budget films . . . have a certain kind of energy and political edge." Wollen's remarks assume a necessary distinction between mainstream feature films like *Chariots of Fire, Gandhi, The Killing Fields,* and *A Room with a View,* and the independents he refers to, who are making B movies in spir-

it, if not entirely in finances. He also isolates criteria—"energy and political edge"—which are useful in speaking of a New British Cinema.

While the idea of a renaissance in British cinema, with its implications of high quality, seems rather farfetched (overall, the quality is not all that high), nonetheless something has happened in filmmaking in this country over the past few years. Without doubt British film has achieved a visibility and identity at home and abroad it has never had before. There have been some notable successes, both at the box office and critically—enough to merit talk by some of a "new wave." This implies, of course, that there were old waves. Perhaps there were, particularly in the British social realist films of the '60s, the mainstream flowering of Lindsay Anderson's Free Cinema. Beyond this example, though, the idea of a school or movement seems forced—the Ealing comedies, the Gainsborough films, Hammer horrors were all studio-based and, while they often shared common styles, hardly represented the political

and aesthetic cutting edge of a new film movement.

Films like *Chariots of Fire, The Killing Fields, Educating Rita,* and *A Room With a View* have encouraged the current high profile of British film in the international press, but such lower-budget productions as Peter Greenaway's *The Draughtsman's Contract,* Bill Douglas's *Comrades,* Stephen Frears's and Hanif Kureishi's *My Beautiful Laundrette,* and Derek Jarman's *Caravaggio* have attracted the most critical praise. They also suggest that there exists in Britain a cinema engaged with its own culture and which has found new ways of expression—and, crucially, which has found an audience as well. These are Wollen's B movies. They do not suffer from the bland visual patina that American money and obvious tailoring for the "international" market have given some big-budget productions. The fate of *Absolute Beginners* is pertinent here. What began as a potentially successful B movie, in Wollen's terms, was reduced to a bland flop by script changes demanded by the

Sammy and Rosie Get Laid, 1987

My Beautiful Laundrette, 1985

American funders. On the other hand, the B movies are usually small-scale, often idiosyncratic; they are marked by personality and have all the energy and edginess that stems from being made independently. The further novelty is that, because they are not narrowly addressed to the avant-garde margins or political fellow travelers, they often attract a young, unusually wide audience.

Three important factors can be pointed to as fostering this upsurge of new, adventurous films: the revamped funding policies of the British Film Institute (BFI); the important role played by Channel 4, with its progressive, broad-based funding and its "Film on Four" series; and the presence of filmmakers who had, by and large, a history of innovation and experiment before entering the commercial domain. Jarman, for example, had been making Super 8 films since 1970 and, working almost in isolation, had made the low-budget causes célèbres *Sebastian, Jubilee,* and *The Tempest* during the '70s. Unbelievably, he had to wait until 1985 to raise funds for his *Caravaggio,* which was eventually made with BFI/Channel 4 money; he filled in the time with more Super 8 films and rock videos. Greenaway, too, had been making his own bizarre and witty tiny-budget films (*A Walk Through H, Vertical Features Remake*) throughout the 1960s and '70s while employed at the Central Office of Communication.

Many of these filmmakers received their early training with very small-scale help from the Arts Council and their own personal finances. In the new, rather hysterical climate in which money is going into productions of all sorts, there is barely any concern for this seeding of young talent. Too many young filmmakers serve no apprenticeship at all before submitting scripts for large-scale productions to the BFI, Wardour Street. The result is at best bad films, and often failure. Furthermore, film and video departments in art schools, still the main area of training in this country for independent filmmakers—both Jarman and Greenaway were trained as painters—are now being systematically starved of money. Students are working with slide-tapes, installations, and photography because departments cannot afford to sustain 16mm film training (even Super 8 is too costly for some!). For many younger filmmakers straight out of college, the pop video world is an obvious attraction—money is available, there is room for experimentation, and there is the hope of moving on eventually to feature films. Quite a few of Britain's younger, ex-art-school talent is working in this area—Sophie Muller (who made the Eurythmics's new video LP), John Maybury and Steve Chivers, and probably many more.

The David Puttnam empire and, at first, Channel 4 were not in any rush to fund filmmakers like Jarman. Equally, the success of Greenaway's *The Draughtsman's Contract* seems to have been the result of accidents. The original film was cut by almost half by the BFI. Originally a much longer film, quite differently and noncommercially paced, it just happened to coincide with a change in funding policies in the early '80s in the BFI Production Board, under Peter Sainsbury. This change of policy—from supporting many small uncommercial (experimental) films to making a pitch for the market by backing fewer films but with bigger budgets—quite miraculously produced a hit immediately. Despite this, though, *The Draughtsman's Contract,* one of the most successful among the independent films mentioned here, has yet to earn a profit. In his most recent film, *Drowning By Numbers,* Greenaway has returned to "play games in an idyllic English landscape."

In 1983, Sally Potter made *The Gold Diggers,* financed by the BFI and very much a risky project. To that point Potter had worked in avant-garde film, performance, and dance. But she had had a small-scale success with her feminist film *Thriller,* made at the London Filmmakers co-op. Ken McMullen, a filmmaker who had made the performance-based *Resistance* in the 1970s and a series of documents on such performance artists as Stuart Brisley and Joseph Beuys, also entered the commercial arena with his *Ghost Dance,* produced by Channel 4. His recent film *Zina,* a mix of political history and fantasy, is a real step toward work which demonstrates an art-cinema aesthetic, unlike the more avant-gardist but awkward *Ghost Dance.*

Wollen's own film *Friendship's Death* was strangely muted and conservative in its approach, like a radio play turned un-

Drowning by Numbers, 1987

Thriller, 1979

imaginatively into film. In the 1970s Wollen and Laura Mulvey had been in the vanguard of filmmakers unwilling to fall into either the fine-art avant-garde camp or the mainstream, attempting instead to stay somewhere between the two. Mulvey and Wollen's *Penthesilea* and *Riddles of the Sphinx* were prime examples of independent film in the '70s. Studio-based and with Tilda Swinton in a leading role, *Friendship's Death* compared badly with Jarman's *The Last of England* (also featuring Swinton), which had none of the rather cold and faintly English intellectual distance one associates with BFI work.

The reasons for the upsurge in this work cannot be reduced simply to economic factors. The 1970s had produced a generation of critics and filmmakers who had been nursed on *Screen* theory, post-'68 politics (mainly French), and avant-gardism. In the mid '70s Mulvey and Wollen were among the first of this group of theorists, along with Chris Petit (*Radio On*) and Ron Peck (*Nighthawks*), to make the break into commercial production itself. And it is in trying to reach a wider audience of moviegoers that adequate funding begins to play a crucial role. In France and Germany, films had long been made with the help of generous central government and city funding; in the 1960s the French New Wave had taken full advantage of this support. Matters were entirely different in Britain, though. Jarman has stated that if he had been in Germany since making *Jubilee* he

would probably have made a feature a year. On a train journey we shared a few years ago, just after he had made the underrated and largely unseen *The Angelic Conversation,* Jarman threatened to move to Berlin in desperation at Britain's lack of funding and interest in his work. Ironically his least interesting film, *Caravaggio,* has been one of his most successful, earning him a nomination for the Tate Gallery Turner Prize in 1986.

November, 1982, saw the arrival of the new Channel 4, with its promise to support "innovation" in film and its reliance on independent producers to supply programs. Channel 4's influence on filmmakers' attitudes has been immeasurable, and its effects are still being felt. The role played by David Rose, the principal commissioning editor for drama, was crucial. The channel has helped finance a number of television films which have also had commercial theatrical release—a virtually unique phenomenon. Rose's support of *My Beautiful Laundrette,* for example, was important in its being made. The film's neat encapsulation of a number of "hot" issues—race, unemployment, Toryism, and homosexuality—made it a hit. It also fit into the English tradition of social realism, doing in the 1980s what *A Kind of Loving, Room at the Top,* and *This Sporting Life* had achieved in the early '60s. Kureishi and Frear's *Sammy and Rosie Get Laid* is within the same tradition, and recently excited the historian Norman Stone into an unfortunate polemic in which he ac-

cused Jarman, Frears, and others of moral turpitude, and pleaded for a return to traditional values in the cinema. Would such values have excluded Edgar Anstey's classic 1930s documentary *Housing Problems* or Michael Powell's *Peeping Tom?* Probably.

Jarman, on the other hand, has never been a realist filmmaker. He owes more to Powell and Pressburger than to the documentarist strand of English filmmaking. Of course, *My Beautiful Laundrette* is a low-budget *mainstream* movie which, like *Mona Lisa* and *A Room with a View,* was a success in the world market but most probably still has not made its money back. Nevertheless, for any film with a budget of over £1.5 million, American money is a must—either through a distribution deal or by having half the budget committed in the United States. This figure is the watershed for independent production in this country. To have more than this amount of financing come from American sources is to incur the American effect, in which scripts are pulverized and any cultural identity is diluted. It is a ceiling many independent filmmakers cannot reach, but more importantly one that many do not want to reach—the price is too high. What is perhaps most heartening in the current scene is the willingness, although still limited, of funders to see films like *The Last of England* (which Simon Relph of British *Screen* described as "within the limits of its budget perfectly commercial") as viable for support at all. Inter-

Friendship's Dream, 1987

The Last of England, 1987

estingly, Jarman's film emptied the cinemas in Britain, but has played to packed houses in Germany.

As one might expect, there are a number of aesthetic strategies at work with the new climate for film. For example, *The Last of England* lacks any real plot; it is shot (quite beautifully) in Super 8, using pixillation and slow motion. Its aggressive editing and uncompromising imagery depict a Britain in the near future run by a fascistic army; in this dark and pessimistic view only personal love seems to provide a spark of hope. Greenaway's work is ruthlessly intellectual, revealing an acerbic wit and love of the conceit, as well as a penchant for strong compositional photography. The mix is quirkily Modernist, with a surrealist twist in its repeated use of obsessive lists as a narrative device. On the other hand, Terence Davis, whose new film *Distant Voices, Still Lives* was made on a low budget co-funded by Channel 4 and Germany's trailblazing ZDF television network, has explored a poetic realism embedded in autobiography, a journey into the interior. *My Beautiful Laundrette* comes out of British television drama, in which Frears has worked successfully for years (his 1978 TV film of David Hare's *Licking Hitler,* for example, was brilliant). Kureishi's excellent script for *Laundrette* pinpoints the important role writers have played in the new British cinema— screenwriter Stephen Poliakoff's recent directorial debut in *Hidden City* (a thriller set in London) has all the hallmarks

of a Wollen B movie; novelist Neil Jordan's *Angel* and *A Company of Wolves* (the latter based on Angela Carter's short story) were both early successes of the new British cinema.

As all this indicates, there is a renewed and general interest in filmmaking in Britain and a new willingness on the part of young filmmakers to enter the commercial world. Experimentalists are approaching Channel 4 for support for their projects. More importantly, organizations like the Arts Council are working with Channel 4 in order to provide regular funding (£20,000 per project) for younger filmmakers. But the overall picture of British film often appears rosier than the reality. After *The Gold Diggers,* Sally Potter returned to making a short film, *The London Story,* funded by the BFI. Jarman still finds it hard to attract major funding, and at every opportunity rails against government policy and American cinematic imperialism. Greenaway has gone abroad for help; since *The Draughtsman's Contract* he has looked to Europe to raise money for his two last films. Meanwhile young filmmakers, the talent of tomorrow, are still starved of funds. The Thatcher government's assassination of the film industry with the Cinema Act of 1983, and the conservatism of the National Film School, mean we are unlikely to produce a New Wave proper. Ironically, the communist Eastern bloc countries and Soviet Union seem able to support a cluster of highly talented filmmakers who are not dominated

by the box-office alone, from the brilliant animator Jan Svankmajer in Czechoslovakia to the late Andrei Tarkovsky in the Soviet Union, who could not have raised a penny in this country or America for films like *Stalker* or *Mirror.*

Whether the funders, financiers, and commercial film community in this country will learn before it is too late that talent does not appear out of the blue but needs support, especially at the level of art colleges and Arts Council small-grant funding, is a question still without an answer. Medium-range low-budget funding—in amounts from, say, £25,000 to £500,000—barely exists here. But this is the very area of film funding in which true film culture can flourish, where ideas can be tested, experiments made, and experiences expressed without the demands of the marketplace breathing down filmmakers' necks. When audiences see a film they do not worry about its budget, but the fact remains that most films require a certain minimum of financing if they are to have a hope of reaching a popular audience. And too often producers and distributors judge projects and films solely on the basis of their commercial viability without really looking at them. In the final analysis, perhaps the crucial questions are whether our culture wants a cinema that will criticize, reflect the complexities of life, and create new ways of visually articulating ideas, and whether it is willing to take the financial risks such a cinema inevitably demands. At present the answer seems to be no.

Hidden City, 1987

Distant Voices, Still Lives, 1988

TROUBLESOME PHOTOGRAPHS
by Trisha Ziff

Troubled Land: The Social Landscape of Northern Ireland, *photographs by Paul Graham with text by Declan McGonagle and Gerry Badger. Published by Grey Editions, London, 1987 ($19.95).*

I had to return to Belfast again to put together my thoughts on Paul Graham's work; to visit some of the places which I, also an outsider to the North (though one who has spent a great deal of time there over the years), also knew.

The pictures have a lifeless quality to them, a feeling of doom. They are empty of people for the most part . . . Chernobyl after the evacuation. There is no sense of community. These are early morning images, taken by an invisible author capturing the day before people emerge, yesterday's newspaper blowing in the wind, old rubbish, the edge of people's lives. His folio of color landscapes of the North of Ireland is titled "Troubled Land"—an evocative title, and succinct. Both words are ripe with history and symbolism in relation to Irish history.

"The Troubles" is a phrase first used during the 1920s, deeply expressionistic and romantic, evoking images of darkness in literature and songs while at the same time working as a euphemism for what people knew only too well. Since the 1970s, the expression has become popularized to refer to the last twenty years, the phase of the war since British occupation. It is used consistently by the British media when referring to events in the North, but as such has a very different connotation than it does to the Irish. In British parlance, it creates a sense of diminished responsibility, a separation from Britain. "Their troubles," in this case, becomes a way for the British to look no further, for fear of finding themselves in the shadows.

"Land," like "troubles," is a word that in Ireland has no neutrality. The Irish people for generations saw their land invaded and taken from them by settlers, by ruthless evictions, by man-made famine, when the land was rendered barren, when thousands of deaths were followed by the emigration of three quarters of the population. To make landscape photo-

Paul Graham, Fading Political Posters, County Tyrone, 1985

Paul Graham, Hunger Strike Protest, Shantallow Estate, Derry, 1984

graphs in Ireland is to engage with the most central and historical aspect of the present-day conflict. Within images of the land, both rural and urban, lies a way of understanding the political panorama in its historic essence.

I remember one day in 1981 traveling across the country of Derry to the funeral of hunger-striker Thomas McElwee. The journey took us through complex landscapes, and as the landscape changed, so did the communities, class, and allegiances of the people. On that day, there was a great deal of tension, and caution, in the loyalist areas. I have never forgotten what my companion said to me: "You can always tell where one of our hunger-strikers grew up. The landscape changes, the fields become smaller and rockier, there are fewer trees and cows, and more rocks and moorland. Our landscape is not so lush, more barren. In these areas, Mother Ireland is an old woman."

For me, Grahams's pictures lack that sense of a changing landscape which is so powerful in Ireland. His pictures have the quality of traveling up a British motorway, where miles of the high grass verges give the impression that nothing changes. There is no sense of the richness, the variety, and the omnipresent struggle within his pictures—these are "neutralized" landscapes.

The historic imposition of the border, when partition in Ireland was introduced in 1921, divided the country unnaturally in two. Today, border and boundaries are a significant part of the landscape, and this Paul Graham addresses by photographing graffiti illustrating the ideological and political division of the two communities. Graffito stating BEWARE (though it is unclear to whom this message is addressed) and paving stones painted in the colors of the Irish flag indicate the picture was taken in a nationalist area; red, white, and blue, the colors of the Union with Britain. Traveling through his landscapes gives an overriding sense of unwelcomeness. To an outsider looking in, there is no invitation or desire to get closer. He photographs the two communities the same way; his position is nonpartisan. From the pictures there is no sense or understanding of what divides these people, other than different colors and letters in graffiti.

What Graham chooses to tell leaves me none the wiser . . . perhaps Graham does not see the role of the photographer as being to inform the audience.

The introductory text by Gerry Badgers states that Graham is one of a new generation of documentary/landscape photographers "who eschew the conventional wisdom of photojournalism." He goes on to say that "the contemporary photographer of the 'social landscape' may be said to be more concerned with the experience rather than history, with the psychological rather than direct political state of being." These pictures, it is true, are predominantly concerned with Paul Graham's experience, rather than the history or politics of Ireland. They convey coldness, alienation. The captions almost indicate a cynicism in their minimalist approach—they reflect a British reserve.

Graham worked in Ireland between 1984 and 1987, a specific time in contemporary Irish history. Yet his landscapes have a monumental sense of timelessness. But these images could have been taken only in the mid 1980s—a time when Thatcher visited Dublin, when the Anglo/Irish agreement was developed, and when Britain was implementing a policy of "normalization" (a term developed by the United States in Vietnam). It was a time when loyalist forces began to reassemble and heighten the sectarian divide in response to Britain and the Free State's discussions. It was three years after the hunger-strikes of '81, which mobilized thousands of nationalists and republicans in the streets north and south of the border. It was a time for reflection as well as action.

While Badger claims that Graham is concerned more with his experience than with history, it is clearly only through understanding history that his pictures have meaning. Ireland, like all countries at war, has at times been saturated with the media. Droves of news photographers produce images of young rioters on the streets of West Belfast and Derry that, by sensationalizing and projecting a reality of shock and mayhem, render their audience numb after constant exposure.

Graham sites his work in opposition to this form of photojournalism. "It is one of the sacred unwritten commandments of reportage," writes Badger, " 'if

you are not close enough, your pictures aren't good enough'—so admonished Robert Capa, doyen of hotspot photographers." In reducing all photojournalism to the sensational, he is leaving out a wealth of work by photojournalists working in the tradition of photographers ranging from W. Eugene Smith to Sebastiao Salgado, whose reportage is neither sensational nor detached.

Many contemporary photographers have chosen to spend years of their lives visiting Ireland and making images that not only inform but change perception, pictures that are not about historically newsworthy moments necessarily, but personal moments that much better explain the public history. Graham attempts to make a "balanced" image of the North by photographing outside the newsworthy moments to portray a more "truthful" image of the gap between normality and conflict. What he achieves instead is to reveal clues of abnormality which we have to search for in a dominant image of a so-called "normal" landscape. His images in both their size and lush color are monumental and rich; they contrast sharply with the tradition of news photography in which he places himself. These are products for the art gallery wall, not for mass consumption.

Ireland for many years was veiled in a curtain of media silence, the result of consistent censorship by Britain over a period of two decades, during which time the media, in Britain and internationally, received "controlled" access and information from the six counties. It was only in 1981, with the hunger strike, that the media ban was broken, when journalists and photographers in large numbers came to see the situation for themselves. This same pattern of censorship is currently employed by the Israeli and South African governments. Given this, it is increasingly the photojournalist's obligation to inform his or her audience of what he sees, thinks, and feels. Photojournalists have the responsibility to act as purveyors of both information and understanding, albeit subjective.

This work is about Paul Graham, not Ireland. The North of Ireland becomes secondary to the structure and intent of his work. I am left confused. Even the British army (included in only one image) appear small, inconsequential, and ab-

surd—like toy soldiers. Whatever position one takes, the reality of armed men on the streets is both powerful and frightening. Yet in Paul Graham's work these figures appear incidental in the landscape. Images of graffiti dominate, propping up the mainstream view that this is a country divided by sectarianism. We are reminded of the British translation of "Troubles"—that this is in fact an "Irish Problem." I cannot help wondering what stylistic method would be imposed by Graham if he were to work in South Africa or Iran. I am reassured when I see the work of photojournalists such as David Goldblatt or Gilles Peress who continue to make images with a sense of passion and commitment, whose work is both innovative in style and content, and who through their work feel free to express their feelings and ideas—from which we learn and change.

REAL BEAUTY
by Liz Heron

In Flagrante, *photographs by Chris Killip, with an essay by John Berger and Sylvia Grant. Published by Secker & Warburg, London, 1988 (£20 paperback).*

The objective history of England doesn't amount to much if you don't believe in it, and I don't . . .
—Chris Killip, *In Flagrante*

In the photograph that precedes this book's title page—one of a series of visual and written epigraphs—a man stands on a beach, painting the scene before him: the sea, a curving line of shore, a twin headland. What we see on the canvas is, we must assume, what he sees, though it's not what the camera shows us is there; a representation within a representation, neither of them more nor less objective than the other. Intruding in each of the images that bracket the main body of photographs is the photographer's own shadow, Chris Killip reminding us once more of his presence, his stance of distance yet subjective engagement, of a personal vision that acknowledges its politics.

Killip has gained a distinguished reputation and much respect through his rigorous and committed approach to a

small number of extended projects. His work is local, yet its themes go beyond those of local concern. His first book, *Isle of Man* (the island off the northwest coast of England, where he was born and grew up), was published in 1980. The photographs in *In Flagrante* were made over the last twelve years, almost all in the North East of England, one of the regions that has borne the brunt of rapid deindustrialization with its coal, steel, and shipbuilding industries now cut down. More specifically, many of the photographs concentrate on a coastal stretch of that region, at the very edges of the land and of its possibilities, where people are pushed to the limits of survival. While they describe recognizable aspects of impoverished Britain in the 1980s, their singularities dislodge literal readings. Killip works in metaphors, fashioning a poetic vocabulary for the inexpressible sense of loss and dislocation experienced by those on the margins.

Although he shuns any claim to documentary objectivity, in describing poverty and industrial decline Killip's aesthetic does recall traditions of documentary realism dating from the 1930s and its revival in the '70s; it can also be situated in the romantic landscape tradition that has flourished within British photography since its early days. But in fusing these elements to a heightened degree, he creates a series of statements more intense and radically more open than either tradition implies.

Contrary to the transcendental view that robs it of social and historical meaning, landscape is neither timeless nor innocent. In scale and composition, the relationship between landscapes and their inhabitants has been recast in many versions. In the classical proportions of seventeenth- and eighteenth-century painting, and those subsequently borrowed from it by photographic pictorialism, landscape dwarfs human figures into insignificance, absents them altogether or foregrounds them in a spatial harmony that denotes and celebrates property ownership. Killip's figures, instead, exist in a fierce tension with it, tilting at odd angles, lowered and enclosed by its background, looming effortfully above the skyline, or shot against it from below. The landscape becomes not only the scene of their conflicts and gestures, it is

Chris Killip, from *In Flagrante*, 1988

part of them, just as they are part of it.

Even where the turbulent poetry of light and sky acquires epic proportions, Killip offers no reassurance of permanence. Landscape's deformations, its scarred neglect, speak of capitalism's exploitive carelessness. One can read these images as indictments of history extending back beyond the present phase of deindustrialization. In the glistening cobblestones of a deserted back street that slopes down to the towering hull of a ship called *Tyne Pride;* in a snow-covered roadway where figures move in solitary silhouette and a scrawled slogan urges "Don't Vote Prepare for Revolution"; in a panorama where horses graze behind advertising billboards—in all these a history of thwarted attachments to place, the enforced nomadism of communities made surplus to requirements, is elegiacally evoked.

The traveling people who appear in some of these pictures—inside their caravans or in makeshift encampments—represent the utmost margins of that process, as do those who harvest coal from the sea, the coal pulled in carts by ponies. Animals appear, not as pets, but with a working function, or as part of an itinerant retinue: terriers and lurchers, the poachers' dogs. The animals too are marginal, an anachronism, a reminder of preindustrial times.

Yet beauty and expansive space can also stand here as lost potentials for free-

Chris Killip, from *In Flagrante*, 1988

dom; in the Romantic idiom, Eden, still sublime, has not been left behind, but has become a harsh earthly Paradise. Lives are shaped by place, but history and social relations can see to it that the place where we belong may no longer belong to us. Many inhabitants of these islands have been overlooked and partly disenfranchised by the very idea of Englishness, a national category that fails to embrace either Britain's diversity of cultures or its separations of class. This sense of disconnectedness is all the more pervasive in the Britain of the 1980s, where hierarchies of ownership and dispossession have become greater and more brutal.

Waste is an emblem for all of this; the waste on the refuse dumps and rubbish tips, on the half-finished demolitions and abandoned sites of earlier industry, is also the waste of human potential through unemployment, poverty, and the enforced narrowing of life. Children are implicated, too, but they remain objects of hope and tenderness, and are never sentimentalized. There's one picture of a child that would be unremarkable were it not for its context in this "fiction about metaphor," as Killip describes his book:

a boy cupping a frog in his hands, intent and curious, happily aware of his own omnipotence.

Unlike many of his contemporaries, Killip works exclusively in black and white—to avoid the overwhelming aestheticism of color. In style and sensibility, his photographs could hardly be further from that artistic photojournalism whose expressionistic surfaces sear the eye with a formal drama that's seductively self-contained. The depth and tonal gradations of monochrome are particularly appropriate to his purposes, to the intimations of time and alteration in his photographs—and to their status as fictions. For Killip, color has too much forced immediacy.

Yet it's precisely this quality that's turned to advantage in some other current photographic work that also comments on the State of the Nation, albeit in very different terms. Anna Fox's *Work Stations: Office Life in London* (Camerawork) and Paul Reas's pictures of shopping malls and supermarkets, *I Can Help* (Cornerhouse Books), both approach it from the other side, the side marked off by the ascendancy of con-

sumerism, suburbanism, and a headlong aspirational pull. They use color in a way that constricts and registers uniformity, suggesting a programmed syntax of choice within apparent freedom and abundance. Here, color is affectless.

Killip stands back from what he photographs, making no icons. Nothing is condensed or reduced through his lens; there are no victims, no heroes. Although those who figure in his photographs have been rendered disposable by the fluctuations of power elsewhere, they have their own energy. It pushes out toward the edges of the frame; energy blocked or trapped or diverted into violence, gathered into bowed humiliation; energy displayed as hardened anger on the face of a man who stands in his doorway while police carrying riot shields occupy the street outside (during the coalminer's strike of 1984); displayed as concentration on the face of a girl with a hula hoop; energy frustrated or expended for bare survival. This is what's most tragic about these photographs: their sheer dynamism—of human lives held in check, stopped up, diminished by their shrunken possibilities.

The book also contains a double commentary in different registers by John Berger and Sylvia Grant. Both write movingly, in response to the photographs, joining angry polemic and imaginative engagement. But the photographs also offer space for other responses, other engagements. Looking at them is like watching pieces of a moving image, with the sound turned off. They're all the more painfully eloquent for that acute silence, for their acknowledgment of what's ineffable.

'70s/'90s: Notes for a Map of British Photography

Describing the history of recent British photography involves marking zones of influence and contours of change. This attempt to present a cross section of current interests and expression in British photography has necessarily excluded the work of many significant artists: Jo Spence, Val Wilmer, Thomas Cooper, Fay Godwin, Richard Long, Mary Kelly, Bill Kirk, the Hackney Flashers, and more. The diversity of work being done

in Britain today suggests that the creative ferment that flourished there in the 1970s continues in the very different political climate of Thatcher's Britain.

Many critics in Britain regard the early '70s as crucial in defining the terms of cultural debates since. At that time new art-historical approaches, emphasizing deconstructive practice and the political dimensions of culture, were coming to the fore in the universities. Many people were drawn to photography because it appeared to be exempt from the canon of art practice, occupying a space between practice and theory and offering a more open interpretation of visual culture than traditional arts allowed. Reflecting this growing interest, a number of scholars, including Mike Weaver, of the University of Exeter and later Oxford, and Ian Jeffries, of Goldsmiths' College of the University of London, had begun to address photography in their courses.

Those years also saw the appearance of a host of alternative spaces and forums—workshops, galleries, education programs, seminars—organized in reaction against London's monolithic concentration of power. In York, Val Williams and Andrew Stockton started Impressions Gallery, one of the first photography galleries outside London; other programs sprang up in regional centers throughout the country, including Manchester, Leeds, Newcastle, Sheffield, and Liverpool. This wave of activity reached Scotland and Wales, too, with both the Ffotogallery, in Cardiff, and the Stills Gallery, in Edinburgh, founded at the end of the decade.

Crucial to this blossoming of photography was the funding provided by the Arts Council, led by Barry Lane, who has been head of its photography programs for nearly two decades. Lane's policy of supporting photographic activity throughout the country contributed greatly to the growth of these regional centers. Under Lane's direction the Arts Council also funded a series of major exhibitions, including historical retrospectives and contemporary surveys, many of which traveled throughout the country. These exhibitions, and the scholarly publications that accompanied them, helped promote a critical reassessment of what British photography had been and what it might become.

Also important in this profusion of regional activity were the vocational schools, which in the early '70s ventured into fine arts with an explosion of new educational initiatives. The growth of programs at the Polytechnics of North Staffordshire, Trent, and Darby, among others, was paralleled by such other developments as the founding of *Ten.8* magazine, supported by the East Midlands Art Council. The Side Gallery, a cooperative in Newcastle upon Tyne founded by Murray Martin and a dozen other photographers and filmmakers, was initially affiliated with Newcastle Poly; today it offers an impressive range of programs including shows of local interest, a series of touring exhibitions, and grants to photographers. Sheffield Polytechnic, also committed to documentary work and to setting up systems of artist support, was the breeding ground for the magazine *Untitled* in the same period. Closely linked to the Polytechnics during this time were the regional arts councils, whose chairpersons often played important roles in the local schools; crossover of personnel was common.

In London, too, this was a time of great change. The Photographers' Gallery, founded by Sue Davies in 1969, provided an important venue for exhibitions, a role it still serves. In the mid 1970s Victor Burgin, at the Polytechnic of Central London, offered a strong model of a theoretical approach to making and understanding work which has proved to have a lasting impact on younger photographers. At the other extreme in the pedagogical argument was the Royal College of Art, which maintained a conservative commercial and vocational orientation in its photography programs. The inception of the magazine *Camerawork,* which grew out of the community-oriented Camerawork Workshops in London's East End, was another landmark of the '70s, as was the founding of Cockpit Arts Workshops, which published *Schooling and Culture.*

Meanwhile, a number of established institutions had begun to include photography in their activities. The National Portrait Gallery, under the directorship first of Roy Strong and then of Colin Ford, offered valuable surveys of work by such figures as Cecil Beaton and Julia Margaret Cameron; Mark Haworth-Booth, at the Victoria and Albert Museum, mounted a series of major exhibitions throughout the 1970s, including *The Land* (1975); and the Institute for Contemporary Art (ICA) began to show contemporary photography as well.

The role of the magazines during this time was equally important. *Creative Camera,* edited through most of the '70s by Peter Turner and in later periods by Judy Goldhill, Mark Holborn, and Susan Butler, was especially influential, publishing a broad range of historical and contemporary work, as well as news and criticism. In addition, such journals as *Screen* and *Screen Education* broke new ground by placing photography in a theoretical framework that included psychoanalysis, feminism, semiotics, and history.

In the '80s, drastic cuts in arts funding and a freeze on hiring in the universities have led inevitably to a consolidation of power and funding in a few established institutions. Under the pressure of locating private funding, many organizations have been forced to appeal to a more general audience, and in the process have lost much of their distinctive identity. Symbolic of the change is the recent opening of the Bradford Museum of Photography and Film. While it includes a number of important archives, this institution—one of the most heavily attended museums in Britain—emphasizes photography's popular uses: in family albums, in advertising, in traditional documentation, and the like.

As the Year of Photography begins in Britain, the creative ferment of the '70s has given way to a period of diversification, in which photography has been incorporated into an increasing number of academic and art programs and institutions as an integral part of the culture. For example, the sprawling Barbican Art Gallery, opened in 1984, regularly features photography as part of its programs, while many commercial galleries now represent photographers alongside their other artists. The direction of the medium may have shifted since the freewheeling days of the early '70s, but its importance continues to grow. British photography's passionately contested past and energetic present point to a creative and challenging future.

THE EDITORS

CONTRIBUTORS

ROSETTA BROOKS, a writer, editor, and curator born in London and now living in New York, is the editor of *ZG* magazine and publisher of a forthcoming book on artist Annette Lemieux. She organized the exhibition *Altered States* for Kent Fine Arts, New York in 1988.

SUSAN BUTLER is a writer and lecturer who lives in London and in Wales. From 1982 to 1984 she was editor of *Creative Camera*, and she is currently finishing a book on contemporary photography by women, forthcoming from Phaidon in 1989.

MARK HAWORTH-BOOTH is Curator of Photographs at the Victoria & Albert Museum, and author of *The Golden Age of British Photography, Bill Brandt: Behind the Camera, Roger Mayne, John Deakin,* and other titles.

LIZ HERON was born in Glasgow and is a freelance writer, translator, and editor living in London. She has been published in numerous periodicals, including the *New Statesman, Guardian, Listener,* and *City Limits.*

DAVID MELLOR is Lecturer in the History of Art at the University of Sussex, England, and author of *Paradise Lost: The Neo-Romantic Imagination in Britain, Bill Brandt: Behind the Camera,* and *David Bailey: The Sixties.* Mellor also was curator for the Cecil Beaton exhibition at the Barbicon Gallery in London.

MICHAEL O'PRAY writes the film and video column for *Art Monthly,* and has been widely published in numerous film magazines.

GILANE TAWADROS is the Education Officer at the Photographers' Gallery, London. She has written for *Third Text,* a magazine of third-world cultural issues, and is working on a thesis for Sussex University on Black women artists in Britain.

CHRIS TITTERINGTON is Assistant Curator of Photographs at the Victoria & Albert Museum.

TRISHA ZIFF is the director of Network Photographers in London. Prior to taking that position she lived in Derry, Northern Ireland, setting up a community photographers' project funded by a Gulbenkian Foundation grant, while working on her forthcoming Ph.D. thesis on images of Ireland.

ACKNOWLEDGMENTS

Many people have generously contributed their time and talents to the production of *British Photography: Towards a Bigger Picture.* For their advice and assistance we are especially grateful to Mark Haworth-Booth and Chris Titterington, of the Victoria & Albert Museum; David Mellor; Mark Boothe of the D-Max group; and John Tagg.

CREDITS

P. 2 copyright the Estate of Bill Brandt, courtesy of Noya Brandt and of Edwynn Houk Gallery, Chicago; p. 3 photograph by John Deakin, courtesy of and permission from the Victoria & Albert Museum, London; p. 3 photograph by Nigel Henderson, courtesy of the Tate Gallery, London; p. 4 photograph by Philip Jones Griffiths, from *Vietnam Inc* (Collier, 1971) courtesy of the artist and Magnum Photos; p. 4 photograph by Don McCullin, courtesy of and permission from the Victoria & Albert Museum, London; p. 5 photograph by Raymond Moore, courtesy of and permission from the Victoria & Albert Museum, London; p. 5 photograph by David Hurn, courtesy of the artist and Magnum Photos; p. 6 photograph by Thurston Hopkins, courtesy of the artist and the Victoria & Albert Museum, London; p. 6 photograph by Tony Ray-Jones, courtesy of Anna Ray-Jones; p. 7 photograph by Roger Mayne, courtesy of the artist and the Victoria & Albert Museum, London; p. 9 photograph by Richard Hamilton (original in color), courtesy of the artist; p. 11 photograph by Edwin Smith, courtesy of the Estate of Edwin Smith and the Victoria & Albert Museum, London; p. 12 photograph by John R. J. Taylor, courtesy of the artist and the Victoria & Albert Museum, London; p. 13 photographs by Hamish Fulton, courtesy of the artist and the Victoria & Albert Museum, London; p. 14 photograph by Peter Cattrell, courtesy of the artist and the Victoria & Albert Museum, London; p. 15 photograph by Simon Dent, courtesy of the Victoria & Albert Museum, London; p. 16 photograph by Garry Miller (original in color), courtesy of the artist and the Victoria & Albert Museum, London; pp. 16–17 photographs by Elizabeth Williams, courtesy of the artist and the Bibliotheque Nationale, Paris; pp. 18–19 photograph by John Davies, courtesy of the artist; pp. 20–21 photograph by Brian Griffin, courtesy of the artist; p. 21 photograph by John Sturrock, courtesy of Network photographers, London; p. 22 photographs by Peter Marlow, courtesy of the artist and Magnum Photos; p. 23 photograph by Stuart Franklin, courtesy of the artist and Magnum Photos; pp. 24–25 photographs by Paul Trevor, courtesy of the artist and the Victoria & Albert Museum, London; p. 26 photographs by Victor Burgin, courtesy of the John Weber Gallery, New York; p. 27 photograph by Paul Graham, from *Beyond Caring* (Grey Editions, 1986), courtesy of the artist; p. 28 photographs by Chris Steele-Perkins, courtesy of the artist and Magnum Photos; p. 29 photograph by Martin Parr, courtesy of the artist and the Victoria & Albert Museum, London; p. 30 reproduction photograph by Bill Stephenson, courtesy of Helen Chadwick; p. 31 photograph by Helen Chadwick, courtesy of the artist and the Victoria & Albert Museum, London; p. 32 photograph by Susan Hiller, courtesy of the Pat Hearn Gallery, New York; p. 33 photograph by Roberta Graham, courtesy of the artist; p. 34 reproduction photograph by Susan Ormerod, courtesy of the Anthony Reynolds Gallery, London; p. 35 photographs by Verdi Yahooda, courtesy of and permission from the Victoria & Albert Museum, London; p. 36 photographs by Mari Mahr, from *A Few Days in Geneva* (Travelling Light, 1988) courtesy of the artist and the Victoria & Albert Museum, London; p. 37 photograph by Karen Knorr, courtesy of the Victoria & Albert Museum, London; p. 38 photograph by Hannah Collins, courtesy of the artist; p. 40 photograph by David Lewis, courtesy of the artist and D-Max, London; p. 42 photograph by David Bailey, courtesy of the artist and D-Max, London; p. 43 photograph and text by Ingrid Pollard, courtesy of the artist and D-Max, London; pp. 44–45 photographs by Zarina Bhimji, courtesy of the artist; p. 46 photographs by Mitra Tabrizian with Andy Golding, courtesy of the artists; p. 48 photograph by Yve Lomax, courtesy of the artist; p. 49 photograph by Susan Trangmar, courtesy of the artist; p. 50–51 reproduction photographs by John Back, courtesy of the Bess Cutler Gallery, New York; p. 53 photographs by Calum Colvin, courtesy of the Salama-Caro Gallery, London; p. 54 photographs and text by Olivier Richon, courtesy of the artist; p. 55 photograph by Ron O'Donnell, courtesy of the artist; p. 56 photograph by Boyd Webb, courtesy of the Meyer/Bloom Gallery, Santa Monica, and the Anthony d'Offay Gallery, London; p. 57 photograph by Adam Füss, courtesy of the artist; p. 58 photograph by Tim Head, courtesy of the Anthony Reynolds Gallery, London; p. 59 photograph by Susan Gamble and Michael Wenyon (hologram), courtesy of the artists and the Victoria & Albert Museum, London; p. 60 photograph by Peter Fraser, courtesy of the Ffotogallery, Cardiff; p. 61 photograph by Peter Fraser from *Two Blue Buckets* (Cornerhouse, 1988), courtesy of the artist; pp. 62–63 photographs and text by Anna Fox from *Work Stations* (Cornerhouse, 1988), courtesy of and permission from Jennie Armour; p. 64 photographs by Paul Reas from *I Can Help* (Cornerhouse, 1988), courtesy of the artist; p. 65 photograph by Andy Wiener, courtesy of the artist; p. 66 photograph by Keith Arnatt, courtesy of the artist; p. 67 photographs by Matthew Dalziel, courtesy of the artist; p. 68 photograph from *My Beautiful Laundrette,* courtesy of Orion Pictures, New York; p. 68 photograph from *Sammy and Rosie Get Laid,* courtesy of Orion Pictures, New York; p. 69 photograph from *Drowning by Numbers,* courtesy of the British Film Institute, London; p. 69 photograph from *Thriller,* courtesy of The Other Cinema, London; p. 70 photograph by Karen Knorr from *Friendship's Death,* courtesy of the British Film Institute, London; p. 70 photograph from *The Last of England,* courtesy of The Sales, London; p. 71 photograph from *Hidden City,* courtesy of Film Four International, London; p. 71 photographs from *Distant Voices, Still Lives,* courtesy of the British Film Institute, London; p. 72 photographs by Paul Graham from *Troubled Land,* courtesy of the artist; p. 75 photographs by Chris Killip, courtesy of Secker & Warburg, London.

VANISHING ARCTIC
Alaska's National Wildlife Refuge

Narrative by T.H. Watkins
Introduction by Edward Hoagland
Photographs by Wilbur Mills and Art Wolfe

Here is a portrait of the Arctic Refuge in what may be its final, untouched splendor. North America's "Serengeti Plain" is living under a threat: the U.S. government is proposing to open the land to oil drilling.

 Vanishing Arctic is an extraordinary tale of a stunningly beautiful land. Author T. H. Watkins skillfully interweaves a lively account of the region's people and history—natural and political—with descriptions of the delightful minutiae of his personal adventures. The photographs, by Wilbur Mills and Art Wolfe, reveal a majestic panorama of wilderness. Yet they also impart a sense of intense intimacy.

T.H. WATKINS is editor of *Wilderness* and vice president of the Wilderness Society.
EDWARD HOAGLAND is an award-winning author.
WILBUR MILLS has photographed the Arctic Refuge for more than a decade.
ART WOLFE has published two books of his photographs.

Published by Aperture Foundation in association with The Wilderness Society. 88 pages, 76 4-color photographs. Hardcover $29.95 until 1/31/89; $39.95 thereafter. Order from Aperture, 20 East 23 Street, New York NY 10010, (212) 505-5555; or from your local bookseller.

"Love and wonder were the photographers, awe and anger wrote the text. Arctic Refuge comes alive in this book—its vastness, its silence, its colors and weathers, its glories of light, its wild species . . ."
—Wallace Stegner

WILL YOU HELP ALASKANS PROTECT ALASKA?

The Alaska Conservation Foundation is a community foundation providing financial support to over 40 of Alaska's grassroots environmental organizations. For information on how you can help ACF protect the Arctic National Wildlife Refuge, Tongass National Forest, and other Alaskan treasures, please write to:

Alaska Conservation Foundation,
430 West 7th Avenue #215,
Anchorage, AK 99501.
Or call: (907) 276-1917